IMAGES
of America

INDIAN LAKE,
HAMILTON COUNTY

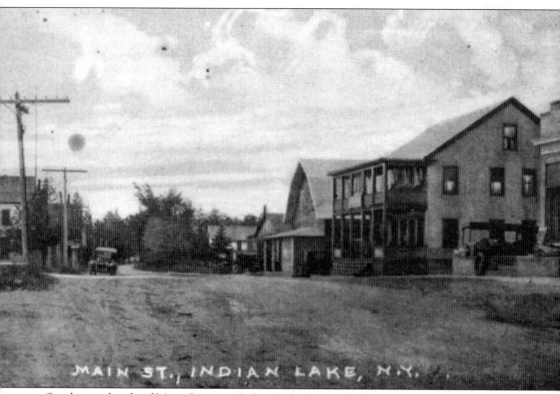

MAIN ST., INDIAN LAKE, N.Y.

On the north side of Main Street in Indian Lake during the late 1800s is the H. A. Palmatier Store, followed by McSweeney's Indian Lake House, Jack Ste. Marie's Saloon, and the Carlos Hutchins Store and Dance Hall. After the Hutchins dance hall is the Tripp Garage. On the south side are the store of Oliver Ste. Marie and the second Commercial Hotel.

On the cover: During the early 1900s, some of the greatest fishing in the world was to be found in the lakes of the central Adirondacks. It was not uncommon to find complete families camping and fishing together. Here on the banks of Indian Lake near the narrows of the Jessup River, a father, mother, and their two sons are enjoying the afternoon sun. The picture is marked "On Old Indian, June 1916" and was originally part of the Margie (Starbuck) Burgess collection. (Author's collection.)

IMAGES
of America

INDIAN LAKE, HAMILTON COUNTY

Arnold W. DeMarsh

ARCADIA
PUBLISHING

Published by Arcadia Publishing
Charleston SC, Chicago IL, Portsmouth NH, San Francisco CA

Printed in the United States of America

Library of Congress Catalog Card Number: 2007930420

For all general information contact Arcadia Publishing at:
Telephone 843-853-2070
Fax 843-853-0044
E-mail sales@arcadiapublishing.com
For customer service and orders:
Toll-Free 1-888-313-2665

Visit us on the Internet at www.arcadiapublishing.com

I wish to dedicate this book to a lady whom many people in the town of Indian Lake have loved and respected for years: my mother, Nellie Mae DeMarsh, pictured here in September 1919. Thanks for being the greatest of moms.

CONTENTS

ACKNOWLEDGMENTS

Very special thanks go to my sister Shelah and her husband, Lynn King; town clerk Julie Clawson; Vaun Lanphear; and all other folks who helped with facts and dates. Special thanks go to my buddies Les Buell and Ira Skinner for their "prodding," and a very, very special thanks to my wife, Mary, for her patience, and to my son Tim and daughter Jen for their assistance. Also credit for many of the facts and dates must be given to longtime friends of our family, Frederick C. (Ted) Aber Jr. and Stella King, now both deceased. While Aber was researching for his and King's book *The History of Hamilton County* (published in 1965 by Great Wilderness Books, Lake Pleasant, New York, and Willard Press, Boonville, New York), Shelah and Lynn worked for him at his home on Sabael Road. A ton of historical "chitchat" was exchanged between them. Many family members and friends were interviewed and contributed information to their book. Lynn and Shelah came away from this experience with a wealth of historical information. I wish to thank them for sharing this information with me. Lynn's mind is like a steel trap. He remembers everything.

Many of the descriptions and dates are also from the postcards themselves and from information written on the backs of the pictures. I also collected information from other family members and from highly respected friends Ned Ovitt, "Coach" George Burgess, Rodney and Marion Moulton, Ralph and Mona Barton, and John Boyea. I thank you all.

INTRODUCTION

The Adirondacks are a mountain range running through 11 counties in the northeastern area of Upstate New York. A large portion of the range is within the six-million-acre Adirondack State Park, which is approximately 40 percent state-owned and 60 percent privately owned land. Right in the middle of the park is Hamilton County, and at the center of Hamilton County lies the town of Indian Lake.

In the year 1843, history was made with the establishment of the first logging settlement in town. Then in 1849, the Wing Lumber Company opened its first sawmill on the west side of the village. These events initiated the development of a community that has since become a destination for thousands of tourists every year. Indian Lake, the lake after which the town was named, was originally three small lakes connected by streams. They were later joined by man-made dams (the latest in 1898) to make the present 14-mile-long Indian Lake.

Lumber was the main resource and the main reason for construction of dams, roads, and bridges during the 1800s, paving the way for the settlements of Indian Lake, Sabael, Lewey Lake, Blue Mountain Lake, Big Brook, Irishtown, Cedar River, Chain Lakes, and Terrell Pond. As the roads improved so too did the tourism to the majestic mountains and lakes of the Adirondacks, or "Dacks" as they are sometimes called today. Great camps for the wealthy families, as well as large hotels complete with rooms, meals, guides, saddle horses, boats, and anything and everything the tourists wanted, were built along the lakes of the central Adirondacks. Beginning in 1871, a passenger train named the Adirondack Railroad, owned by Dr. Thomas C. Durant, ran from Saratoga as far north as North Creek. Here the passengers boarded the two- and three-horse-team Tally-ho Stagecoach, the Wakeley Stage Line, or the Blue Mountain Stage Line, to make the rough journey to Blue Mountain Lake and Raquette Lake. A quick rest stop was made at the North River Hotel, a small hotel on the Hudson River just below the North River Hill. More frequent stops were made at the hotels in Indian Lake. Thus the town of Indian Lake grew as rapidly as the other two settlements. A golden era of the Adirondacks had begun.

Business was booming at the hotels along the lakes and in the villages. In the town of Indian Lake and adjoining Sabael, the Commercial (or Ordway) Hotel, the Indian Lake House, the Indian River Hotel, the Arctic Hotel, and the Cedar River Falls Hotel were enjoying success. At Blue Mountain, the Blue Mountain House, Holland's Blue Mountain Lake House, the Ordway House or American Hotel, and the luxurious Prospect House of Frederick C. Durant were also at the height of their glory days. Some of the hotels at Raquette Lake that were enjoying the boom of tourism at this time were the Antlers, Isaac Kenwell's Raquette Lake House, the hotel of Charlie Bennett, the Grove House, and Fletcher's Forked Lake House, to name a few.

As with everything in life, all good things must come to an end. So too did the Adirondacks' golden era. Things started to quiet down during the first few years of the 20th century. The "big money" was gone and so was the major tourism. Many of the large camps were abandoned, and many of the major hotels were destroyed by fire or simply closed their doors forever. For history lovers, only photographs of many of these beautiful, majestic buildings remain today.

Enjoy the pictures and postcards of the area that I called home during my childhood. My only wish is that I had been a better listener and a more conscientious preserver in my younger days. If I could go back and spend time with my great-grand-relatives, I would be the happiest man in the world.

One

EARLY YEARS
ON THE MAIN STREETS

Indian Lake Village is located at the intersection of Routes 28 and 30 in Hamilton County. There are no stoplights in the town. There is a stop sign only on Route 30 as it T intersects with Route 28 at Main Street. The T intersection has not changed since the town roads were formed during the 1800s. There is no major road running north at this main junction. Coming from the south and taking a left at this intersection, one can follow Routes 28 and 30 northwest to Blue Mountain. Here the routes split. Route 28 heads west to Raquette Lake, and Route 30 goes north to Long Lake and Tupper Lake. If one turns right onto Route 28 at the T intersection in Indian Lake, the eventual destination will be North River or North Creek to the southeast. Farther south, Route 28 connects with Route 9 and the Northway. Route 30 runs south to Sabael, Speculator, and Wells and connects to other southwest destinations.

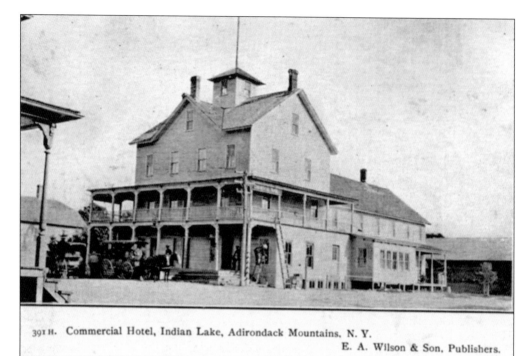

391 H. Commercial Hotel, Indian Lake, Adirondack Mountains, N. Y.

E. A. Wilson & Son, Publishers.

The first Commercial Hotel built on the southeast corner of the village of Indian Lake was a two-story structure. It was the hotel of Beriah Wilbur and was destroyed by fire in the mid-1800s. A new hotel was built on the same site by P. R. Ordway named the Ordway House. Again the hotel burned, and again it was rebuilt, this time by James Hickey in 1917. The hotel burned for a third time and was never rebuilt. A small store was erected on the historic site by Harland and Gretchen Fish, and it was later owned by Beecher and Eleanor King. Jackie Hall now owns the building with plans to open an ice-cream parlor.

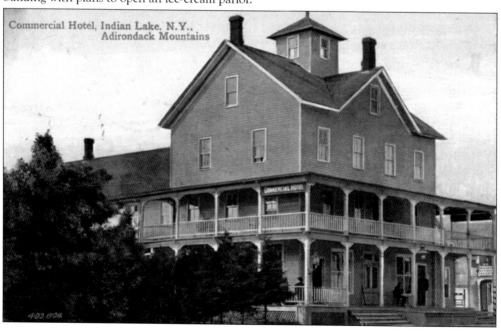

Commercial Hotel, Indian Lake. N.Y.,
Adirondack Mountains

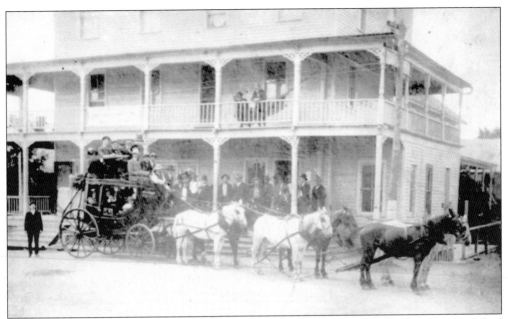

This is the Commercial Hotel, or Hotel of James Hickey, with the Tally-ho Stagecoach parked in front. The coach, complete with trumpet player blowing out the door, was heading for Blue Mountain. Many locals are standing on the porch, ready to make the fanfare send-off complete. The banner stretched across the upper porch reads, "Guaranteed Painless Dentists Are Here Today."

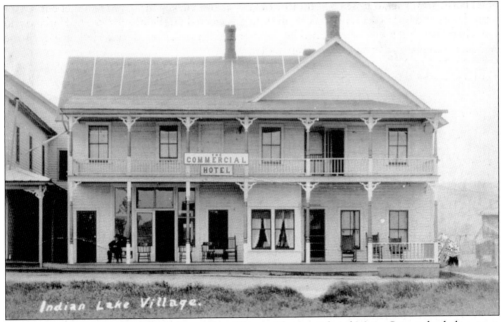

The second Commercial Hotel, located on the southwest side of Main Street, had the exact same name as the hotel standing on the southeast corner of town. They had no connection; they simply had the same name at the same time in history. Today this Commercial Hotel still stands at the same location but is now called Marty's Hotel and operated by Walter Harr.

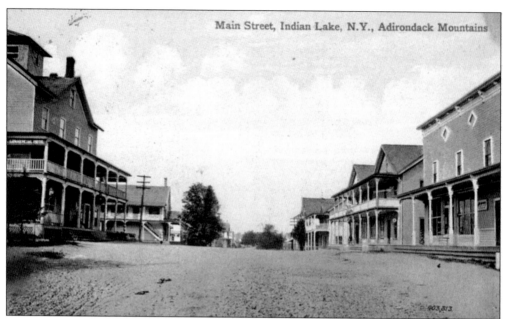

Built on the south side of Main Street are the Commercial Hotel, Ste. Marie's Store, and the second Commercial Hotel. On the north side of Main Street are the Nelson Ste. Marie Store and Hardware, followed by the Wilson and McGinn Company Store, or the H. A. Palmatier Store, McSweeney's Indian Lake House, the saloon of Jack Ste. Marie, and the Carlos Hutchins Store and Dance Hall.

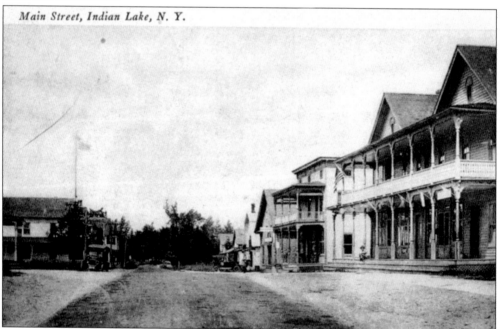

Main Street, Indian Lake, N. Y.

Looking west down the north side of Main Street, one can see the H. A. Palmatier Store, followed by McSweeney's Indian Lake House, Jack Ste. Marie's Saloon, and the Carlos Hutchins Store and Dance Hall. The Tripp Garage is after the Hutchins dance hall. On the south side are the store of Oliver Ste. Marie and the second Commercial Hotel.

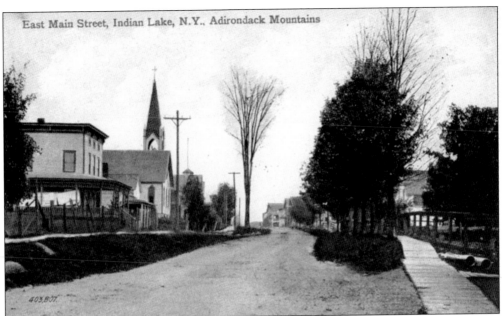

East Main Street, Indian Lake, N.Y., Adirondack Mountains

Many old-timers talked about how slippery the wooden sidewalks were when wet. One can imagine how muddy the dirt streets might have been without them. On the south side was the Carl Montgomery family's private home, a lovely old house originally built by George Richardson. The home sat next to the Methodist church. North Main Street was the location of a small business district of stores and hotels.

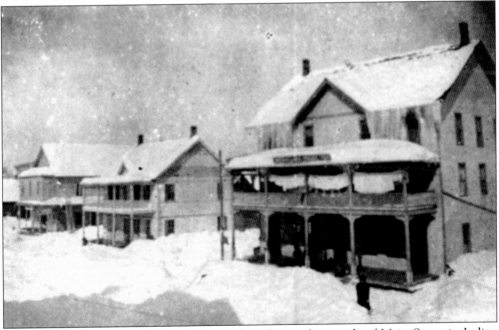

Since the 1800s, the buildings have changed on the northwest side of Main Street in Indian Lake, but the scenery remains the same. On a typical winter day one can still find snowbanks and observe people shoveling them. These high banks, photographed in the late 1800s, are in front of the hotel of Edward McSweeney.

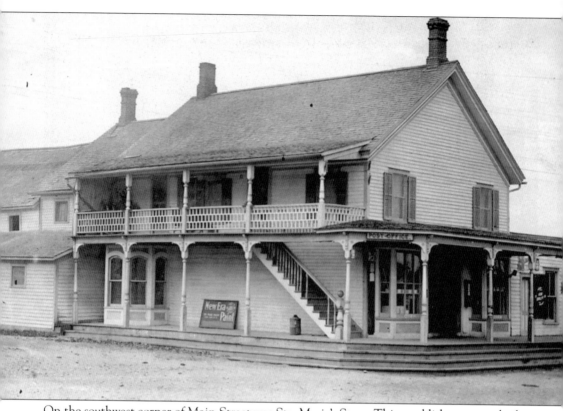

On the southwest corner of Main Street was Ste. Marie's Store. This establishment was built in the 1870s by Isaac Kenwell and sold a few years later to Oliver Ste. Marie. The store was always known for its general merchandise. Anything and everything was available, including clothing, footwear, cattle feed, ammunition, fishing gear, groceries, and prime cuts of meat. Guy Ste. Marie assumed ownership after the passing of his father, Oliver. In 1945, Douglas Fish inherited the store and was a successful owner for 15 years. Other owners included Frazier Jager, Helene Jager, and Peter and Mary Farrell. For many of these owners, the job of store manager was entrusted to Beecher King, with Marie (Turner) Hall as the ever-faithful bookkeeper. The building now houses a floor-covering business and antique shop owned by the family of Peter Hutchins.

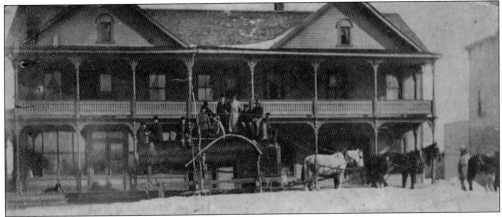

The H. A. Palmatier Store was built in the 1880s and was operated before 1909 by Wilson and Company. What is pictured in the front of the old store? Town historian William Zullo believes it to be the boiler for the Indian Lake Mill Company, which belonged to Sanford Brooks. Others believe it might be a boiler off a small train engine. Either way, this is truly a fascinating historical winter scene.

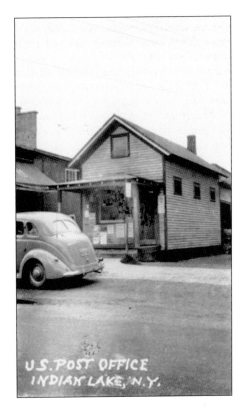

The first official post office was established in 1860 at Eagle's Nest at Blue Mountain, in the township of Indian Lake. The post office building used during the early 20th century, pictured here, was located on Main Street, directly north of the main intersection of Routes 28 and 30. This structure was used for many years, until a new facility was built on Main Street, west of the old Turner Electric building.

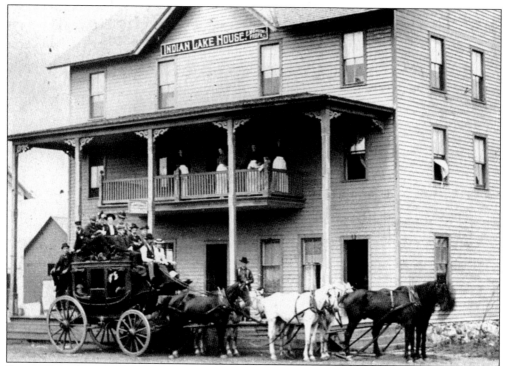

Pictured on the balcony of Edward McSweeney's Indian Lake House are the chambermaids donned in their long white aprons. They were preparing to clean the rooms of the departing guests who had already boarded the morning stage. From here, the stagecoach would cross the street to the Commercial Hotel, where more passengers would board the already overflowing transport.

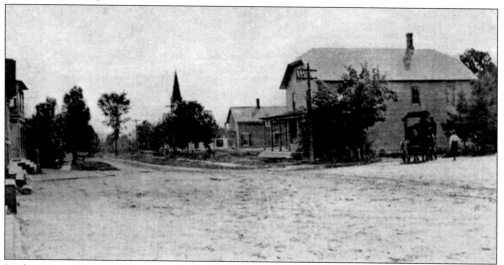

In this view, a horse and buggy is hitched at the old Odd Fellows hall on southeast Main Street. In addition to lodging the local chapter of the fraternity of Odd Fellows, this building also housed the Utowana Rebekah lodge, the sister sorority of the Odd Fellows. Local officers of the Rebekah lodge during the 1930s included Julia Bonesteel as noble grand and Anna Benton as recording secretary.

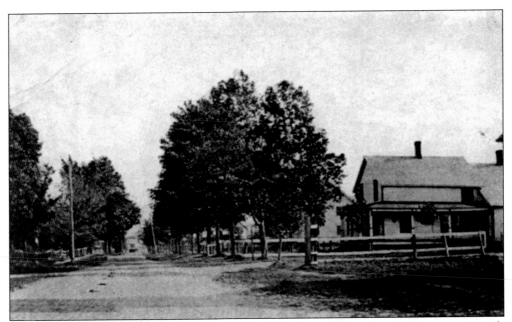

The portion of Route 30 traveling south from town was originally named Maple Avenue, with good reason. With all the huge sugar maples that adorned the streets heading south, east, and west in the village of Indian Lake, it is a wonder that *maple* was not included in the town's name. The private home on the west corner belonged to the Helmsworth family.

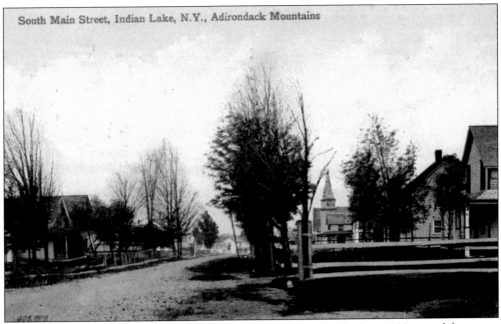

South Main Street, Indian Lake, N.Y., Adirondack Mountains

Maple Avenue was also named South Main Street, and during the late 1800s, a rail fence ran along both sides of the dirt road. At this time in history, the maple trees are very immature, and the houses are sparse. The Baptist church, on the right side of the street, was completed around the year 1892.

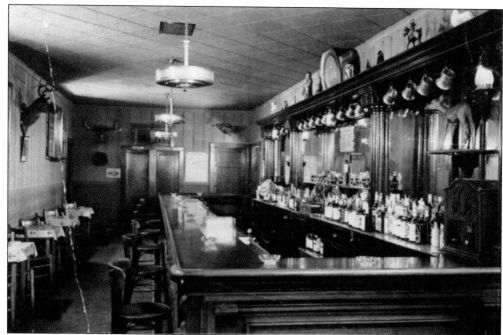

This famous old bar, still in existence on Main Street, is presently known as the Oak Barrel Bar and Restaurant. The bar inside the establishment was moved from Princeton, New Jersey, complete with pewter mugs of undergraduates from the Ivy League school. For several years, Frank and Marie (Severie) Farrell ran a successful business here. It is now owned and operated by John and Ann (DeFilippo) Miller.

During the mid-20th century, Bob Squires owned this restaurant and bar located on the south side of Route 28, west of the village of Indian Lake. Subsequent owners included the Hanson family and the Parson family. It is now the 1870 Bed and Breakfast, owned and operated by Roxanne Eichler.

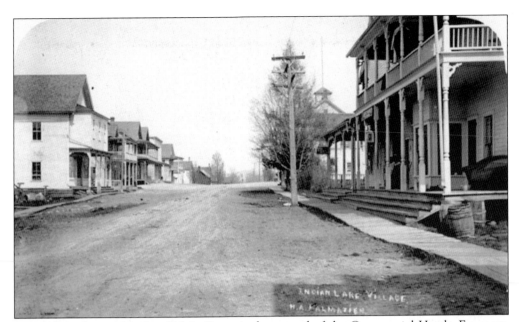

Pictured on the south side of Main Street is the second of the Commercial Hotels. For years, William Carroll ran a meat market downstairs and an undertaker's parlor upstairs. The town clerk's office was also in this hotel. Farther east was Oliver Ste. Marie's store and the first Commercial Hotel. Buildings on the left side of the street belonged to Carlos Hutchins, Jack Ste. Marie, Edward McSweeney, H. A. Palmatier, and William McCane.

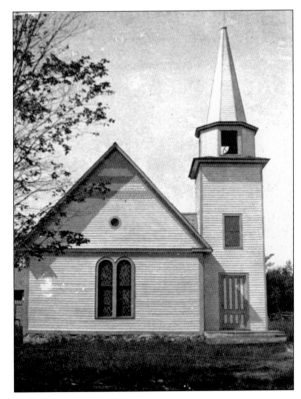

There are presently four churches serving the people of the town, one of which is the First Baptist Church of Indian Lake. Several families that moved to Indian Lake from the Washington County area in the 1870s were among the founding members of the First Baptist Church. Construction of the present building was completed in 1892.

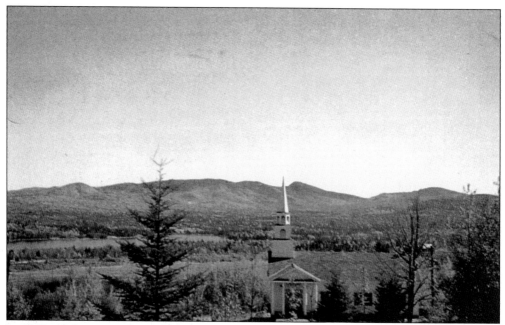

In 1948, a religious group under the leadership of Rev. Fred Howenstein left the First Baptist Church and formed an independent church. The congregation had a house of worship built, known as the Independent Baptist Church, at the top of Christian Hill south of the village of Indian Lake.

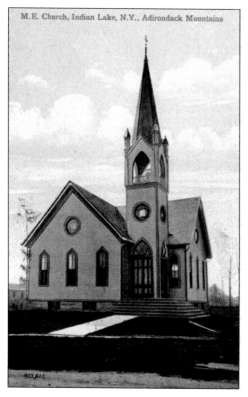

The First Methodist Church of Indian Lake was completed around 1879. The Second Indian Lake Methodist Church opened in 1902, with C. L. Jenkins acting as pastor. The congregation celebrated its 50th year of worship in this building in 1952. The church continues to serve the people of the community to this day.

The first St. Mary's Catholic Church, standing on the northeast side of Main Street, was incorporated in 1894 with Rev. Michael F. Gallivan as pastor of the church. Additions were made to the church in the 1920s. This building sufficed until the congregation outgrew the size of the church, at which point a plot of land next to Indian Lake High School was purchased from longtime resident Ethel Tripp. A new church, complete with a rectory, was built here in 1959. Rev. James M. Flattery served as the first pastor at this new church.

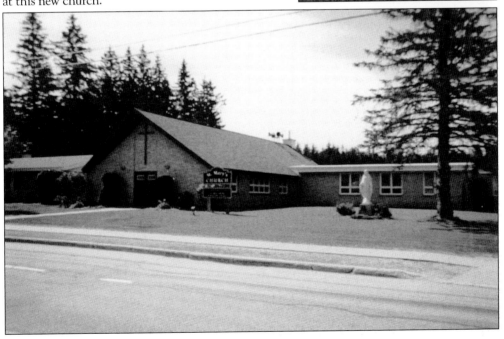

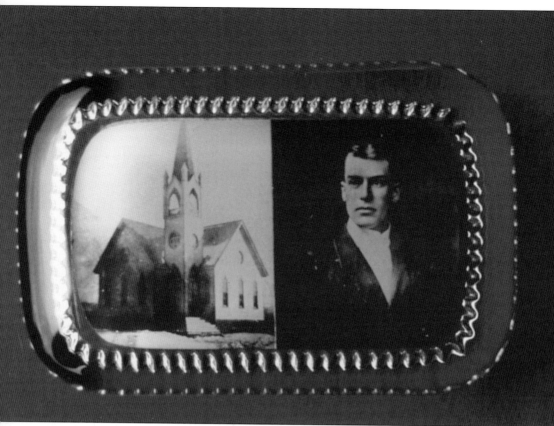

Traveling salesmen and photographers were prominent figures during the 1800s and early 1900s. Well known to the area were photographers J. G. Holley of Schroon Lake, B. V. Reinecke of Albany, and A. Le Mix of Warrensburg. Pictures, portraits, and cabinet photographs featuring these photographers' seals appeared regularly in old family albums. Companies that sold wares in the area included the Grand Union Tea Company, the Jake Seigel Company, and the Grand Trunk Railroad Company. Their products were unique and varied. One of the more popular items during this time period was glass paperweights. They appeared in many sizes and shapes. This paperweight measures four inches by two and a half inches by one inch and was manufactured by Wilfred Smith and Company of New York City. It displays an image of the Second Indian Lake Methodist Church of 1902 as well as its pastor, C. L. Jenkins. (Author's collection.)

Two

WILLIAM MCCANE'S STORE

The McCane building is one of the few original 19th-century structures remaining on Main Street. Several buildings on the north side of Main were destroyed by the town fire of 1921. This major disaster was brought under control when the townspeople decided to blast the Nelson Ste. Marie Store with the use of dynamite. This created a firebreak, stopping the raging flames just west of the McCane building. According to William (Bill) McCane, when he replaced his roof years after the disastrous fire, he found, among other things, what he believed to be Mattie Ste. Marie's sewing shears stuck in the shingles on the west side of his roof. The paint on the west side of his store was also blistered and peeled, and some of the glass in the upstairs windows had melted from the heat of the fire. This, according to McCane, was a day in history that he would never forget. One can only imagine the intensity of the fire that destroyed those large, dry, wooden buildings, especially with the very limited firefighting equipment of the time period. Come April, a ritual took place at McCane's store and home. Everything had to be coated with a thick layer of enamel paint. The porches had layers of slippery, gray paint added, windows were painted shut with white paint, woodwork was painted, the front stairs were varnished, and the back stairs were painted. Even the handles of his tools had layers of heavy green paint. After a few years, the garden tools were so coated, they were almost too heavy and slippery to use. Spring meant paint at the McCane residence. Also McCane made his own ice cream in a small building behind the store. He had his own engine with a pulley belt system, icehouse, and storage unit, all finished in beautiful wainscot oak. For many years, McCane ran the store on the first floor and lived on the second floor with his wife, Lillian, and mother, Meta McCane. In 1943, he closed his store forever, and the first floor was rented by the Village of Indian Lake for town office space.

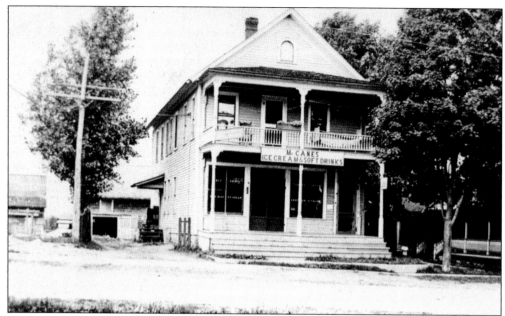

William (Bill) McCane, born on October 25, 1890, was the oldest son of George and Meta McCane. After graduating from Indian Lake schools, McCane began his career as a lumberjack. After a few years in the woods, he turned his attention to operating a store and ice-cream parlor on the northeast side of Main Street. Here he hand made some of the finest ice cream in the Adirondack area. McCane also carried local newspapers, groceries, souvenirs, and specialty items that catered to the local townspeople. His establishment was also a place where local organizations could freely advertise their upcoming events. The large picture windows on his porch were a perfect venue to display their announcements.

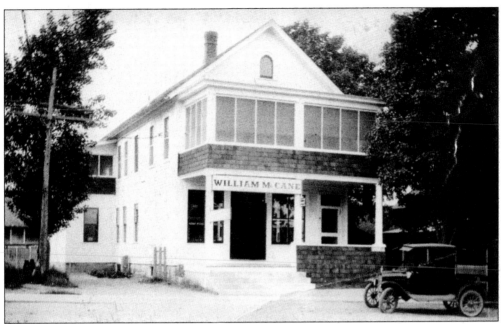

Before the fire of 1921, the driveway at the William McCane building did not extend all the way to the back of the store. Standing to the west of the driveway was the McCane Barbershop. Around 1915, William's brother, John McCane, was the town barber at this establishment. At one time, a second chair in the barbershop was operated by George "Ken" Edinger. Edinger later opened his own barbershop next to the Commercial Hotel on the southwest side of Main Street. Pictured are John McCane with his wife, Clara (Hutchins) McCane, and their infant daughter, Blanche. John was born on February 28, 1891, and died in April 1987. Clara was born on June 30, 1890, and died in December 1980.

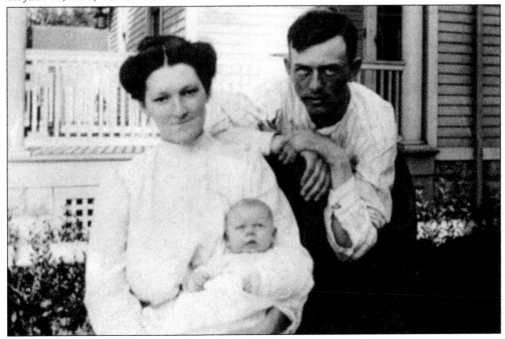

How closely knit can the families of Indian Lake be? Pictured, from left to right, are Orrin "Ott" Lanphear, William McCane, Elizabeth (Hutchins) Lanphear McCane, Clara (Hutchins) McCane, Hazel (McCane) Lanphear, and John McCane. Orrin Lanphear had married Hazel McCane and therefore was brother-in-law to the two McCane brothers. Elizabeth (Hutchins) Lanphear McCane was originally married to Orrin's brother Melvin Lanphear until he died; Elizabeth then married William McCane. Elizabeth's sister Clara married John McCane. This made John Elizabeth's brother-in-law in two different ways (both because he was married to her sister Clara and because she was married to his brother William); for similar reasons, William McCane was Clara (Hutchins) McCane's brother-in-law twice. Think what family reunions were like. For example, Elizabeth had 15 siblings. At one time in her life, she had eight in-laws on her first husband's side and eight in-laws on her second husband's side. The confusing part was three in-laws on each side were the same people.

Three

JOURNEYS MADE TO INDIAN LAKE

The Delaware and Hudson Railroad line was built from Saratoga Springs to North Creek in 1871 by Dr. Thomas C. Durant. At that time, Durant was general manager of the Union Pacific Railroad, a branch of the Transcontinental Railroad. About 1889, the railroad became the Adirondack branch of the Delaware and Hudson Railroad and was sold to William W. Durant. Ideally it was hoped that the rail lines would carry through to Long Lake and points farther north. However, this plan never materialized, and North Creek became the final stop. This small train delivered passengers for the stagecoaches bound for the northern towns of Indian Lake, Blue Mountain Lake, and Raquette Lake during the last quarter of the 19th century. The Tally-ho Stagecoach, the Wakeley Stage Line, and the Blue Mountain Stage Line all met passengers at this North Creek station. Later in about 1940, a 30-mile extension was added to the tracks to reach Tahawus, where valuable raw materials needed in the manufacture of equipment and airplanes for World War II were mined.

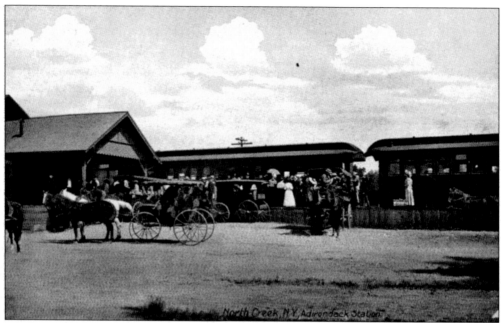

At the station in North Creek, the passengers boarded stagecoaches to reach their final destinations to the north in Hamilton County. After their tiring trip from Saratoga, passengers found comfort a short walk down the street at the hotel of Henry Straight. Straight's Hotel, in the late 1800s, was on the main road, about where the North Creek Bank is now located. Many weary travelers spent the night at Straight's Hotel after riding the Adirondack train to North Creek. Here they could appreciate a restful night's sleep before continuing their journey. In the morning, they would board the northbound stage. As with the fate of many of the Adirondack hotels, Straight's Hotel was destroyed by fire in 1919.

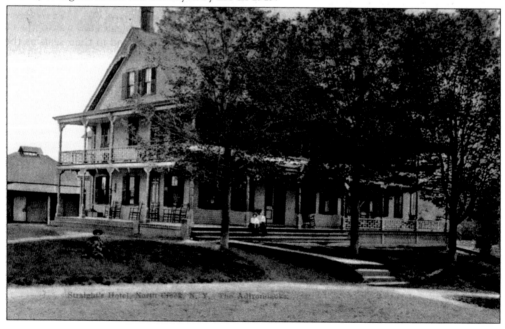

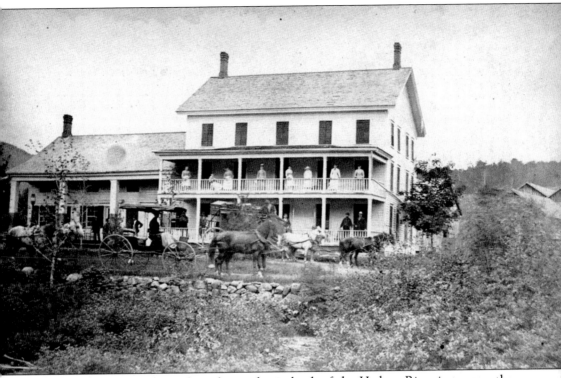

The North River Hotel, located on the southwest bank of the Hudson River just across the Indian Lake–Hamilton County border, was owned in the early 1870s by William Wakeley. A few years later, Wakeley sold the hotel to R. B. Scarritt and W. Eldridge and began building his Cedar River Falls Hotel on a remote area of the Cedar River in the town of Indian Lake. The North River Hotel was the usual lunch stopover for the northbound stagecoaches out of North Creek. Apparently lunch had been served, because the hotel guests are exiting the building in this early J. F. Holley cabinet photograph. The stagecoaches and buggies are waiting to be boarded. All passengers spent the next several hours being jostled around in their seats as the coaches navigated the rough and bumpy roads, trying to reach their final destinations.

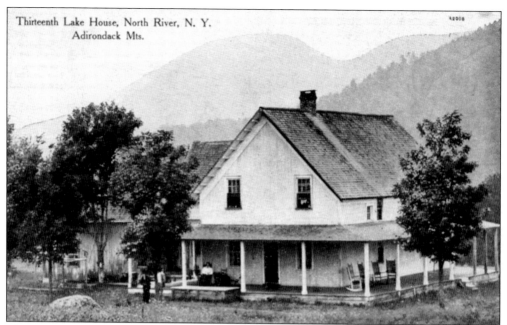

The Thirteenth Lake House was built in the mid-1800s on Thirteenth Lake in North River. It was located on the route taken by many of the French Canadians and other settlers of Little Canada and Big Brook. Many of the settlers had come to this country as lumbermen, but as the lumber industry waned, they turned to farming in the remote areas of Warren and Hamilton Counties.

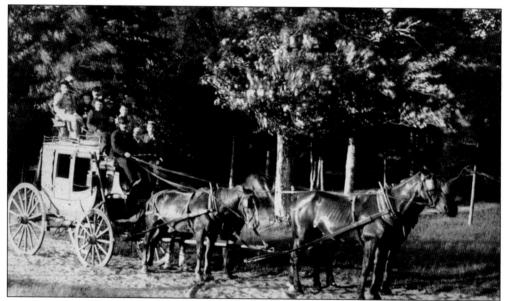

On the back of this old photograph is crudely written, "Wakley's [sic] Stage Line—Runs from North Crick [sic] to Indian Lake Cedar River A [and] Blue Mt Lake." William Wakeley built the Cedar River Falls Hotel in the 1870s, only to see it destroyed by fire. He rebuilt it twice, and each time flames consumed the property. Wakeley furnished his own stage line to his property on the Cedar River.

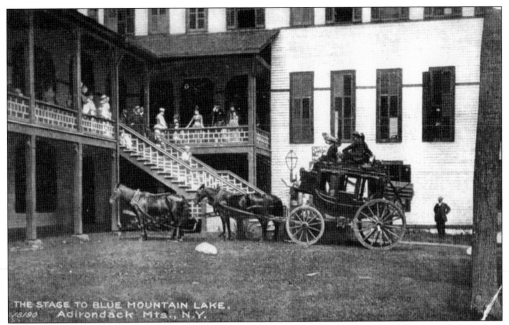

Marked across the top of this old stagecoach is Blue Mountain Stage Line. The coach is parked behind the famous Prospect House. Guests on the balcony and stairway are patiently waiting for the unloading or the departing of the stage. This hotel on the south point of Blue Mountain Lake was built in 1881 by Frederick C. Durant. The Prospect House sign is visible in front of the driver.

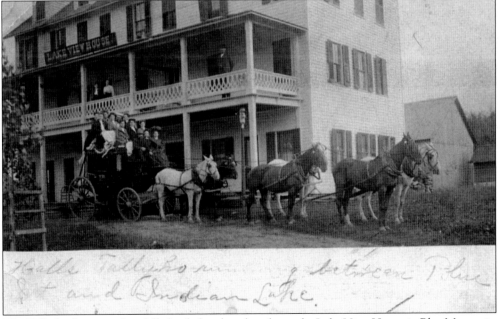

The Tally-ho Stagecoach is fully loaded and ready to leave the Lake View House in Blue Mountain Lake. The Lake View House was a small hotel built by John Sault and Anslow Truesdale in the 1880s and was destroyed by fire in 1899. Handwritten on the bottom of the card is, "Halls Tally-ho running between Blue Mt. and Indian Lake."

31

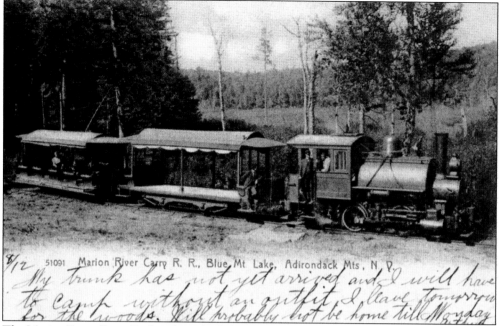

The Marion River Carry Railroad was built by William W. Durant around 1900. Possibly one of the shortest railroad lines ever, its tracks measured less than one mile in length. Its function was to skirt the rapids of the Marion River between Raquette Lake and Blue Mountain Lake. The train simply ran back and forth along the short section between the two towns. A small boiler engine, converted from coal to oil, pulled a baggage car and two passenger cars. The engine's boiler was replaced twice during the years the railroad serviced the area. Tourists also had the choice of being transported by a little steamboat owned by Dr. Thomas C. Durant, which was known as the *Killoquah*.

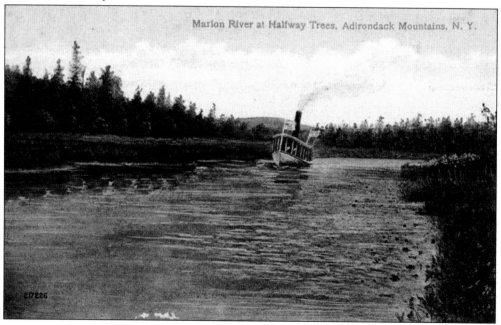

Marion River at Halfway Trees, Adirondack Mountains, N. Y.

Four

BIG BROOK

Many of the earliest of the settlers in the Big Brook area of Indian Lake made the journey from the town of Johnsburg, Warren County, via the Thirteenth Lake trail, and settled in the section known as Little Canada. Others ventured farther south toward Milo Washburn's sawmill and west toward the waters of Big Brook. Yet others came south from the village to settle along the Round Lake Brook. Many had originally come to the area as lumberjacks and then turned to farming. Families such as Eldridge (store owner), Osgood, Dumars, Starbuck (stonecutter), Fish, Lanphere (one of many spellings), Payne, Porter, Savarie, Daniels, McCormack, Hunt, Hutchins, King, McCane, and Bennett built homes along the brooks south of the village and east of the lake itself. These were hardworking people. The land was stony, uneven, and tough to farm. There was little grazing land for their valuable livestock; therefore, much of the land had to be cleared. It was miles back to the village of Indian Lake for supplies, and the roads were difficult to navigate while riding in an old horse-pulled buckboard. Life was challenging for these early homesteaders, but Big Brook became an established community. The names of the families listed above are still visible on the mailboxes throughout the Big Brook area.

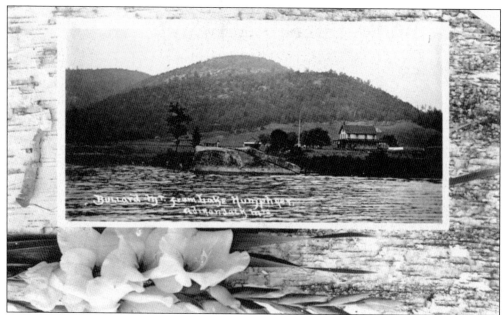

At the end of Big Brook Road is the Chimney Mountain House. It was opened around 1920 by owner and manager Charlie Carroll. It was a small boardinghouse on the shore of Lake Humphrey, also known as King's Flow. The resort was later sold to Harland and Gretchen Fish, who, in turn, sold it to Douglas Fish. At one time, the caretakers were Lester P. and Lois (Hutchins) King. Now this beautiful remote location is a privately owned Scout retreat camp. Bullard Mountain looms over the main lodge and camps at this scenic resort. Below, dinner is pecking on the lawn of the first camp constructed at Chimney Mountain.

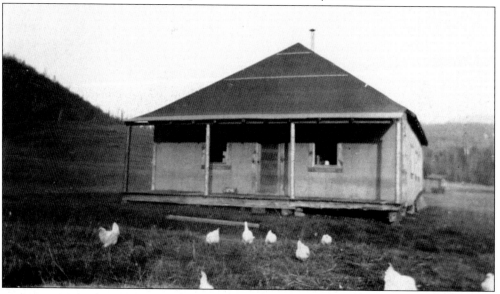

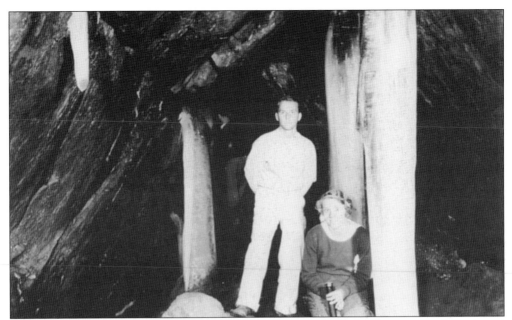

The caves on the top of Chimney Mountain are tempting, but the descents are difficult and dangerous. Many times the novice tourist has needed assistance with the ascent to the surface. The stalactites and stalagmites keep the caves cool and refreshing all year round, as the ice remains a permanent fixture.

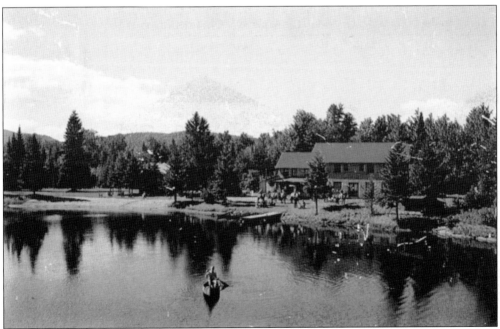

Wilderness Lodge, built in 1938 by Howard King, was once the site of Milo Washburn's sawmill. King named the body of water Emina Lake after his children Emett and Ina. The lake was later named Rainbow. There was an iron bridge that crossed a small dam. Disaster struck when the dam broke and most water was lost, leaving only a small stream. The dam was never rebuilt.

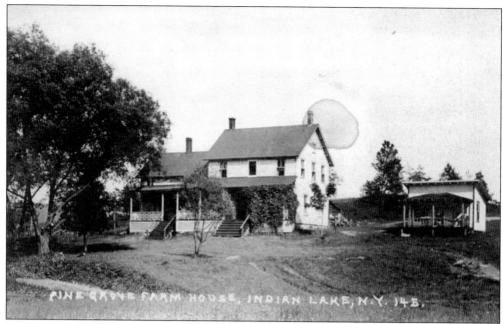

This small boardinghouse, named the Pine Grove Farmhouse, was located before the entrance to Camp Sabael east of Indian Lake. It had a capacity for about 20 guests with rates of $15 per week. About 1925, the proprietor was Jerry Severie. The old farmhouse still stands facing the ledges that hide the view of Indian Lake.

The first known dam on Indian Lake was built around 1845 to connect two or three small lakes. This dam was built to facilitate the floating of logs by the early lumbermen. A second dam, forcing the water to overflow more of the surrounding land, was completed during the 1860s. The construction of the state dam on Indian Lake, shown here, was executed by the Indian River Company in 1898.

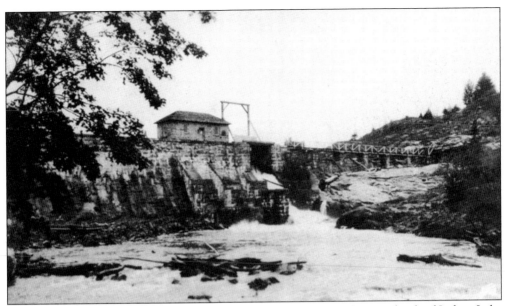

A few years after the completion of the state dam, the trees on the west bank of Indian Lake were just beginning to grow. The dam was built in 1898, creating a reservoir to supply clean drinking water to the townspeople of Indian Lake. The second view, taken from the west shore, encompasses the caretaker's house and farm. The farm was built on the east shore as a dam-keeper's residence. The area could be reached by taking Big Brook Road south of town to Severie Road and on to Dam Road. There was no direct road to the dam from Sabael Road.

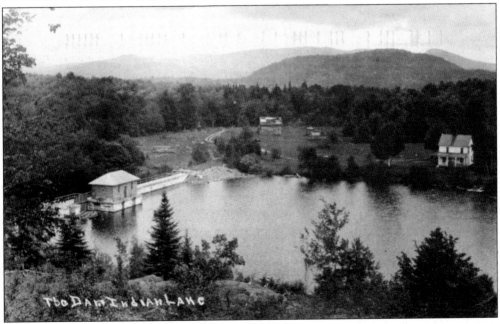

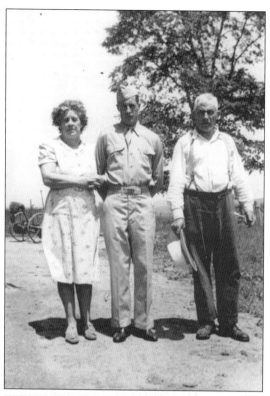

Early dam-keepers included Lester Severie and John Tracy Sr. Tracy lived at the caretaker's house with his wife, Sophrina (Bennett) Tracy. She gave birth to 17 children. Pictured here in 1943, the Tracys are enjoying a visit with their son Bernard, who was home on leave from World War II. Today's caretakers are Darren and Penny Harr.

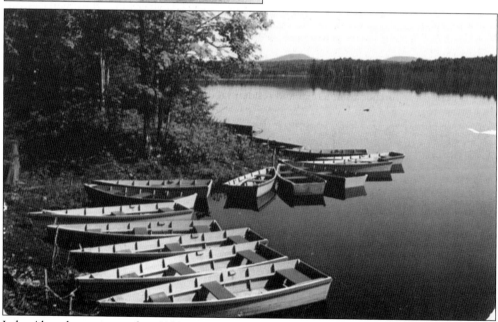

Lake Abanakee, so named in 1954, is a man-made lake. The lake runs directly north from the outflow of Indian Lake. It follows the old riverbed for about four miles, flows back to the Indian River, and finally is absorbed into the Hudson River. At the Big Brook crossing, a half-mile causeway was built. At the northwest end of the causeway lies Locke Harbor, originally owned and operated by Viola Locke.

Five

LEWEY LAKE AND SABAEL

The post office listing for the Lewey Lake House is Indian Lake, but Lewey Lake actually lies in the town of Lake Pleasant. The outlet of Lewey Lake flows east into the west shore of Indian Lake. One of the first settlers near Lewey Lake, close to the time of the Civil War, was guide Alvah Dunning. He was followed by the French Canadian hermit and lumberman Louis Seymour, better known as "French Louie." French Louie had several cabins and shacks near Indian Lake, Lewey Lake, and Newton's Corners and remained in the area until his death in 1915. William Ferguson also settled on the shores of Lewey Lake and assumed ownership of the original Alvah Dunning cabin. Soon after his death, Ferguson's brother sold all properties to Ellen (Locke) McCormack. The settlement consisted of a main lodge and log cabins. The McCormacks owned and operated Lewey Lake for about 13 years. During the next several years, other proprietors of Lewey Lake included Elmer Osgood, Levi Osgood, Halsey Galusha, John (Jack) Burgess, Martin Harr, Paul Burgess, and then members of the Galusha family again.

This period saw further commercial and residential development north of Lewey Lake, along the eastern shore of Indian Lake, in the area known as Sabael. Hotels, boardinghouses, dance halls, stores, and private residences came to dot the landscape from Lewey Lake to the village of Indian Lake. Sabael became another thriving community in the township of Indian Lake.

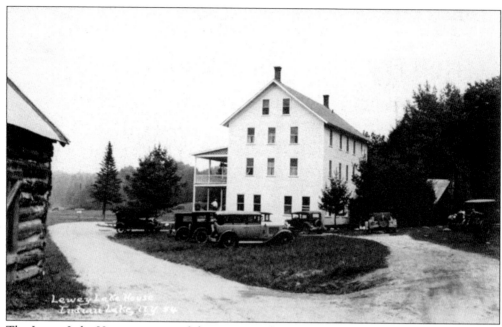

The Lewey Lake House was one of the most popular resorts in the Adirondacks. This can be attested to by the number of guests' automobiles parked near the main lodge in this photograph. The lodge was surrounded by several old log cabins, lean-tos, and camps that housed tourists seasonally from April to October. Boats were also available for the guests for fishing and recreation, as Lewey Lake offered some of the finest fishing in the Adirondacks. Standing on the porch of the main lodge in the photograph below are believed to be members of the Osgood family, owners of the resort during the late 1800s and early 1900s.

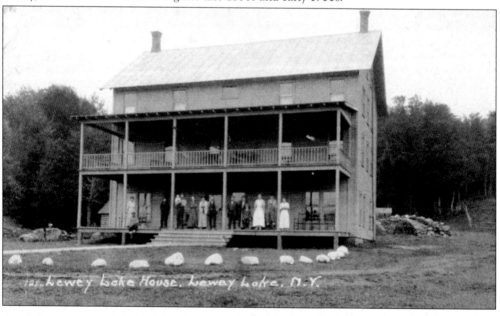

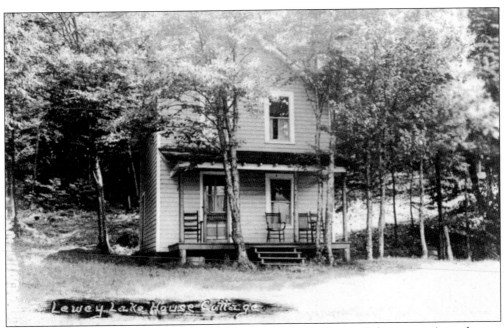

Beautiful, native white birches surround this cottage at the Lewey Lake resort. According to the owners in 2007, who are the daughters of Lynn Galusha, this was known as Grandma's Cottage. They also believe the picture below may have been taken from the approximate camp location of Sam Seymour. Seymour lived in a cabin on the opposite shore from the famed French Canadian hermit Louis "French Louie" Seymour. Sam always claimed to be a relative of French Louie, a claim that French Louie emphatically denied. Both hermits roamed the land around Indian Lake and Lewey Lake, but French Louie gained the most fame.

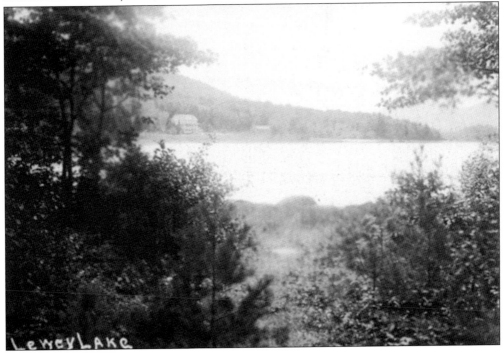

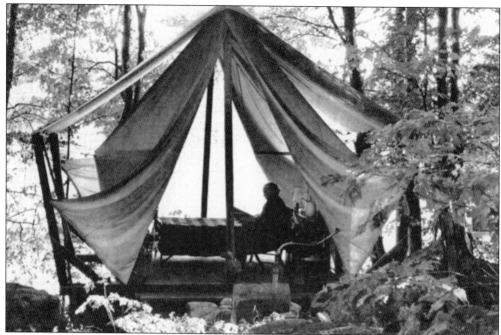

According to *Back Log Camp—In the Adirondacks*, a brochure of general information and rates from March 1957, Back Log Camp was originally founded on an island in Lake George by Thomas K. Brown, a Quaker schoolteacher from Pennsylvania. After two years, the camp was moved to the Thirteenth Lake area. Later the camp was moved again to Raquette Lake. In 1911, land was purchased on the Jessup River area of Indian Lake. The camp continues to function today in this remote location as a privately owned summer camp. There is always a breeze at the headwaters of the lake, and above, one of the campers at Back Log is taking full advantage of its coolness. A second camping area used by the Quakers, pictured below, was near King's Flow in the Big Brook area.

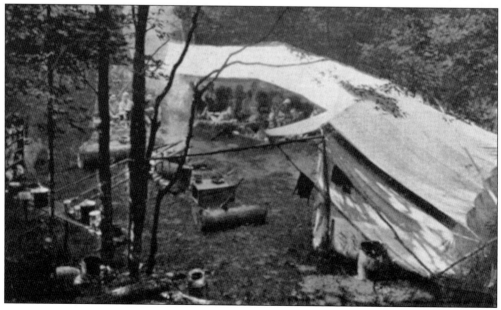

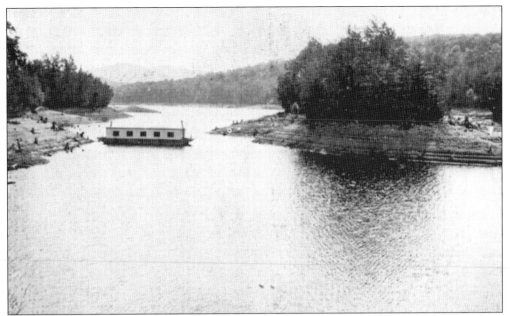

Johnny Mack Bay is a section of Indian Lake southeast of Long Island and sits just east of where the narrows begin on the lake. The depicted houseboat belonged to John (Jack) Burgess, who was a local guide, lumberman, sportsman, and businessman. The old houseboat was still a familiar sight into the 1940s, traversing the waters of Indian Lake and navigated by the grandchildren of Burgess.

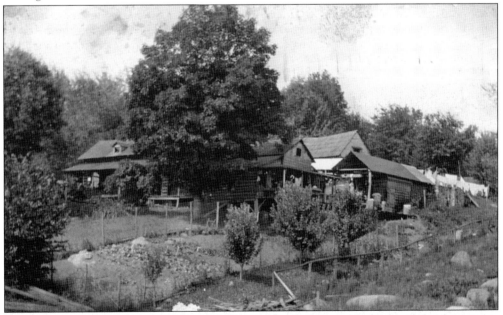

Today Adirondack gardeners are forced to fence their garden areas to prevent the destruction of their plants and trees by the grazing of the white-tailed deer. This has not changed since the early 1900s. The gardens at Farrington's Hotel were completely surrounded by a restrictive, high fence. This seasonal resort was located west of Johnny Mack Bay and Indian Point, about where Forks Brook empties into Indian Lake.

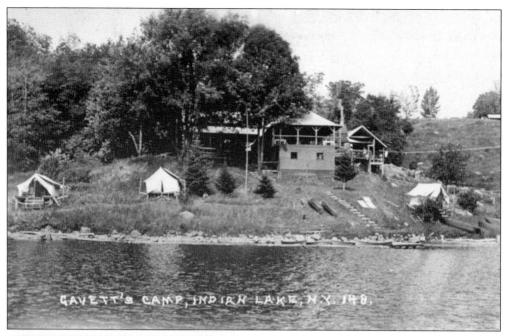

GAVETT'S CAMP, INDIAN LAKE, N.Y. 148.

During the late 1800s, this resort, Farrington's Hotel, was owned and operated by the family of Gertrude Farrington. In 1921, the hotel was sold to Ted Gavett. For years, Gavett ran the northern part as a camp for boys. Gavett's Camp was leased to the Beach family from 1937 until 1952, when the Gavett family again assumed ownership. The overflows of tourists were housed in camps and tents that were scattered throughout the encampment. Some of these tents were sprawled across the lawn and along the shoreline of Indian Lake. Today the seasonal resort area is known as Timberlock and is owned and operated by the Bruce Catlin family. The picture to the left is of Harland and Bernice (McCabe) Farrington, early proprietors of Farrington's Hotel on Indian Lake.

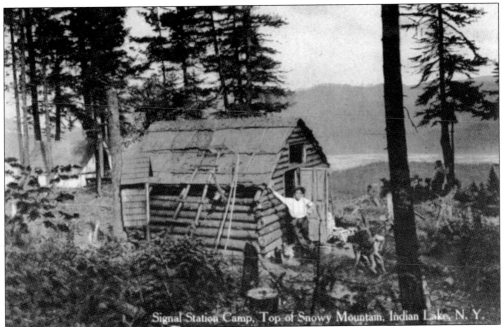

Signal Station Camp, Top of Snowy Mountain, Indian Lake, N. Y.

Snowy Mountain, rising about 3,900 feet above sea level, is the highest mountain in Hamilton County and of the southern Adirondack range. Originally named Squaw's Bonnet by the earliest settlers of the area, Snowy Mountain has become one of the more popular hiking trails in New York State. The first fire tower on Snowy Mountain was completed in 1909. It was replaced in 1917 by the present steel structure. A quaint shanty was a good way to describe the ranger signal station at the top of the mountain around 1900. The shear ledges on the face of Snowy Mountain are intimidating, to say the least. This precipice was created by the snow and ice landslides of the harsh Adirondack winters.

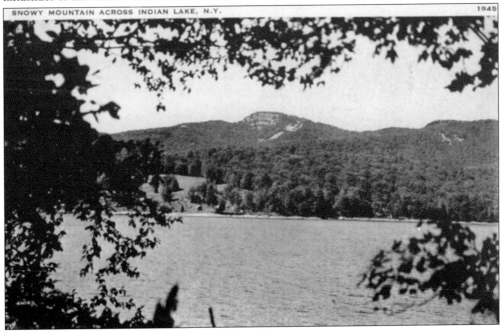

SNOWY MOUNTAIN ACROSS INDIAN LAKE, N.Y. 1945

During the 1880s, this split rail fence ran from the George Griffin farm south along the Griffin Flats toward Snowy Mountain. The old dirt road ran farther south, all the way to Newton's Corners, the town now known as Speculator. Griffin Farm and Cabins were located on these flats just north of Snowy Mountain. Lumber jobber George Griffin and wife, Lucy, lived on this farm during the 1860s, with their children Charles, Sophronia, George W., Mary, Charlotte, and Emma. Here the Griffins ran a small boardinghouse. They catered to lumbermen who worked in the areas of Indian Lake and Lewey Lake. Many worked as lumberjacks for Griffin. He was not only their lumber jobber but also their landlord.

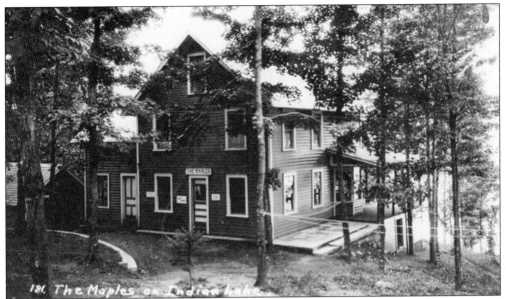

The Maples was situated on the western shore of Indian Lake off Lake Shore Drive facing east. It was a small boardinghouse that also housed a store and an ice-cream parlor. It was owned and operated by Louis King and his wife, Edith (Locke) King. Except for the maturing of the trees and a few physical changes to the doors and windows, the Maples remained the same for years. What a pleasure it must have been for the owners and guests of this small boardinghouse to venture onto the porch and witness the rising of the sun over the pristine waters of Indian Lake morning after morning.

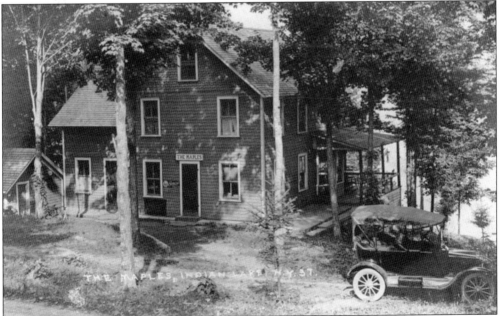

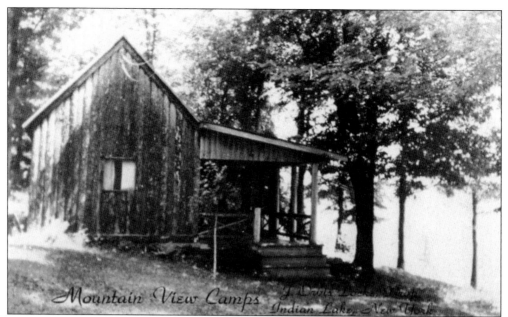

This is one of several housekeeping camps off Lake Shore Drive owned and operated by J. Orvis Locke. Amazingly the same families returned to the same resort establishments in the area of Indian Lake generation after generation. Indian Lake survived from the revenue generated by summer tourism. Locals knew the names of the returning tourists, and the tourists appreciated the hospitality. They became known as extended families of the town.

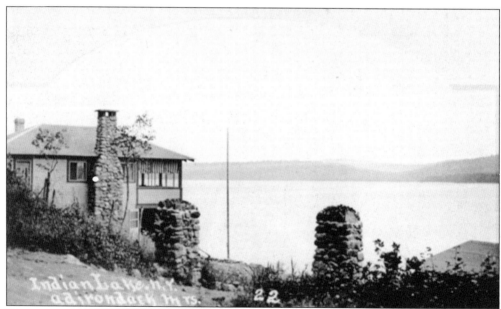

This is an example of a late-1800s private home that was built facing east on the shores of Indian Lake. This beautiful house, complete with fieldstone pillars, was originally owned by the Allen E. Lent family and more recently by the Joseph Bush family. Today another family enjoys the comfort of this old house and hopefully is able to reap the benefits of living so close to the lake.

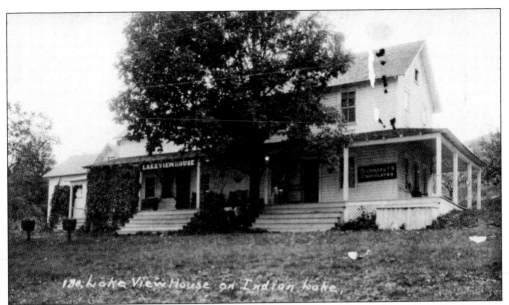

The Lake View House is an original 1800s boardinghouse and remains standing today in the community of Sabael. At one time, this resort was owned and operated by the William Carroll family. Later owners included Olive Carroll, the Pashleys, the Henchels, and in 1950 William and Pearl Daubenschmidt. This is an early view of the Lake View House before the addition of the fireplace and the moving of the front steps. In the picture below, the appearance has changed slightly but still remains picturesque. The beautiful, big tree that was too unique to cut is still growing through the porch roof. According to the current owner, the old tree has since been removed.

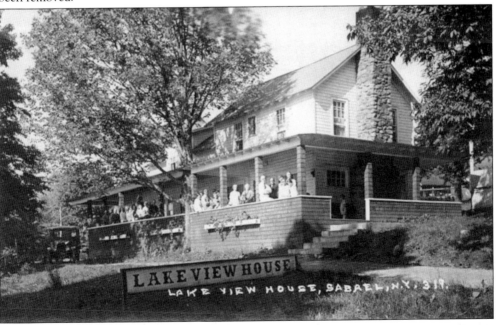

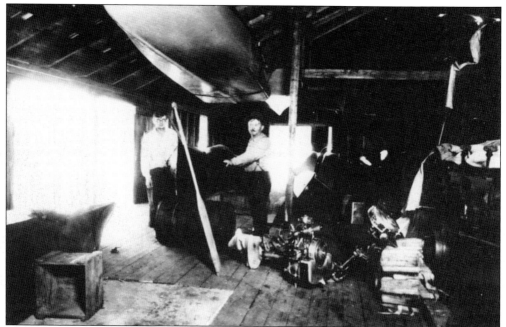

William Kerst, who was born in the 1870s, owned and operated a sawmill near the Indian River Bridge during the first few years of the 20th century. This was located east-southeast of the village of Indian Lake near the Indian River Hotel. Then with son Leo, William opened a boat landing and boat motor repair shop off Lake Shore Drive in Sabael. This father-and-son team became renowned for its uniquely skilled craftsmanship. Here in this quaint little shop, the Kersts handcrafted some of the finest Adirondack guide boats, canoes, and wooden motorboats in the area of the central Adirondack lakes. William and Leo are pictured above in their repair shop and below standing next to their signature boats.

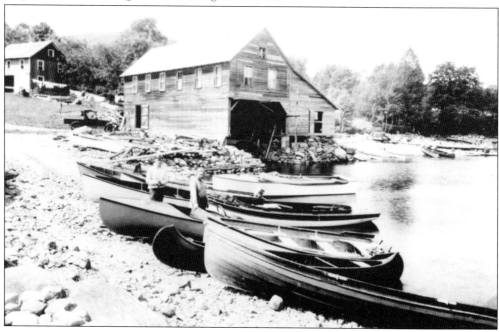

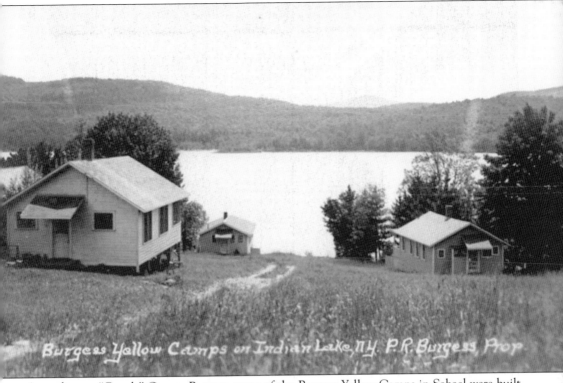

Burgess Yellow Camps on Indian Lake, N.Y. P.R. Burgess, Prop.

According to "Coach" George Burgess, some of the Burgess Yellow Camps in Sabael were built by his father, Portus R. Burgess, with the help of Martin and Randall Locke. Two other cottages were purchased from a neighbor. The main house was across the road west of the cabins. It was originally purchased from the Porter family. It is possible that Portus R. Burgess purchased the home from family member Annis M. Porter. She is listed in the 1900 Indian Lake census as part of the Burgess household. The 1900 census also lists father John, age 45; mother Mary, age 31; son John, age 12; son Eugene, who was known as Vinton, age 9; daughter Lucretia, age 7; son Portis (Portus), age 6; daughter Iva (Eva), age 4; and son Paul, age 1. Others living within the household included mother-in-law Mary Lawrence, age 55, and grandmother-in-law Annis M. Porter, age 78. Another son, Earl, was not yet born and oldest daughter Myrtle had died at age seven of black diphtheria. For over 30 years, Portus R. Burgess ran a successful block ice business from a small icehouse constructed behind the main house.

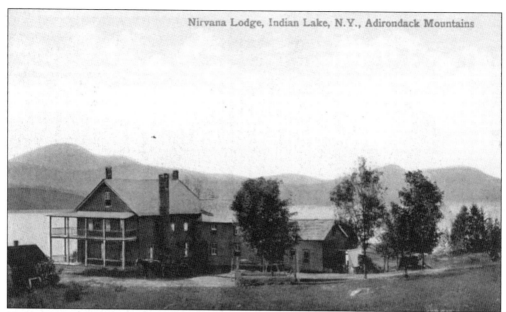

Nirvana is a word often connected with Buddhism or Hinduism. It can also mean freedom from pain, worry, or the external world. Knowing the location and the beauty of Nirvana Lodge, one can only believe that "freedom from pain, worry, or the external world" was the motivation in its naming. Nirvana Lodge was, at one time, the summer home of the Lindsey Best family. Later the Morgan and Evatt families were owners of this magnificent estate. It was a beautiful setting off Lake Shore Drive, facing the rising of the sun. It consisted of a main lodge, a dock, camps, a lean-to, and tenting areas. No late-19th- or early-20th-century lodge, camp, or hotel would have been complete without the well-worn path to the privy. A Sears, Roebuck catalog may have been on hand.

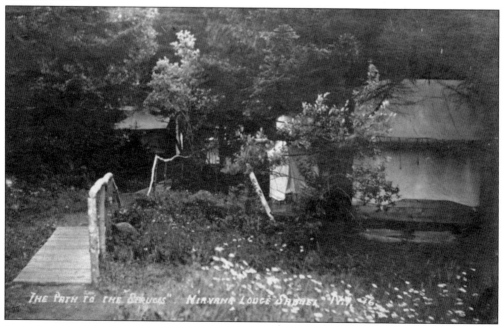

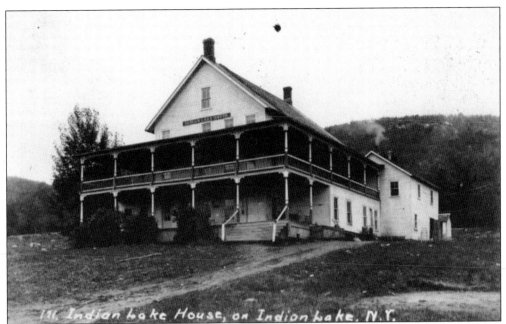

This charming hotel, named the Indian Lake House, was built in the 1890s on a hill facing Indian Lake by James and Ellen (Porter) McCormack, who were the original owners and operators of the Lewey Lake House. The Indian Lake House then passed to Elmer Osgood, who later sold to Dr. Howard Bonesteel. During his proprietorship, Bonesteel changed the name of the hotel to the Bonesteel Cottage. After a few years, he sold to Ralph and Julia Bonesteel, who renamed the hotel Indian Lake House. After years of managing the Indian Lake House, Ralph and Julia Bonesteel sold the old landmark to Andrew Christ.

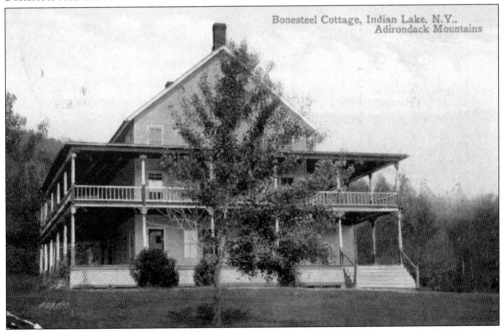

53

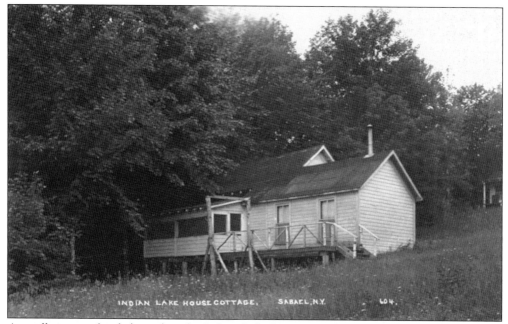

A small cottage that belonged to the Indian Lake House was for several years used as an extra room for family members and guests of the hotel. The current owner of this cottage and hotel is Andrew Christ's daughter Clair Schultz. The hotel is no longer in operation but remains standing as one of the few representatives of a golden era in the Adirondack Mountains.

Locke is a very salient name in the history books of Indian Lake, especially in the formative years of Sabael. There were proprietors of hotels and dance halls, lumbermen, carpenters, and store owners named Locke. Ralph Locke, a carpenter, lived in this pleasingly old-fashioned little camp off Route 30 in Sabael during the early 1900s.

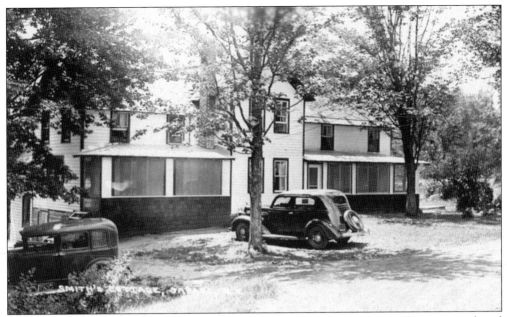

Smith's Cottages, located on the western shore of Indian Lake in Sabael, was owned and operated by Byron Smith. It is still a very busy and popular resort area. The cottages are owned and operated by Smith's daughter Eris Golde Thompson, who also owns the famous Lake Store south of Smith's Cottages.

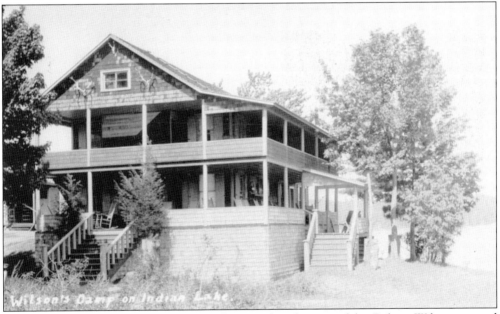

Wilson's Camp on Indian Lake, originally owned and operated by Robert Wilson, opened in 1915. The camp's advertising stated, "We are strictly for comfort and aim to create an environment conducive to health and happiness. Courteous personal service." Wilson's Camp offered horseback riding, tennis, fishing, canoeing, swimming, mountain climbing, and hiking. Wilson's Camp encompassed approximately 30 acres on the western shore of Indian Lake, featuring rooms, cottages, and tenting areas.

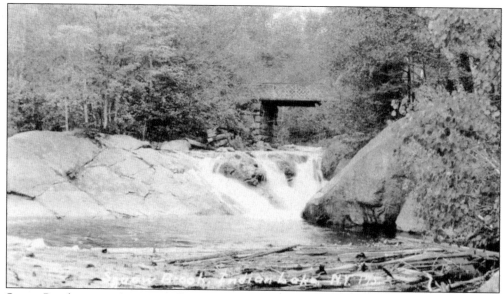

Squaw Brook is one of seven small streams flowing west to east into Indian Lake. They include Squaw, Lawrence, Griffin, Wakely, Forks, Falls, and Sucker Brooks. The story is told that Chief Sabael Benedict of the Abenaki tribe came to Indian Lake from the province of Quebec, Canada. He was the first Native American to settle at Indian Lake during the 1760s. Years later, after his wife died, he buried her body near the mouth of the stream. Thus the stream became known as Squaw Brook, named in honor of the chief's wife. It is believed that Benedict lived to be 110 years old, dying in 1855. An old iron bridge once spanned the rapids of Squaw Brook, followed by a more modern concrete structure.

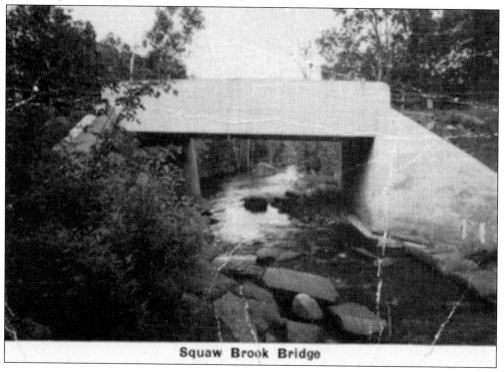

Squaw Brook Bridge

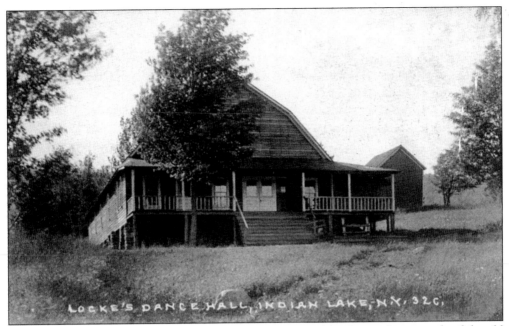

Locke's Dance Hall was built in the late 1800s by Nathaniel Locke on the west side of the old Indian Lake–Speculator Road. This dance hall was in no way connected with the Locke House of Hosea Locke. The small shed pictured by the dance hall still exists today west of Camp Driftwood in Sabael.

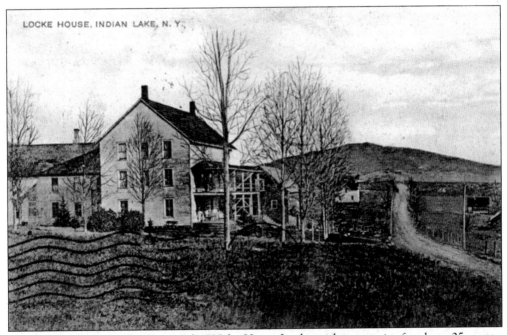

The Locke House was built around 1890 by Hosea Locke with a capacity for about 25 guests. It was unique for the time period, boasting its own nine-hole golf course, tennis courts, riding horses, and a dance hall, complete with local musicians. The Locke House passed between several owners during the first few years of the 20th century.

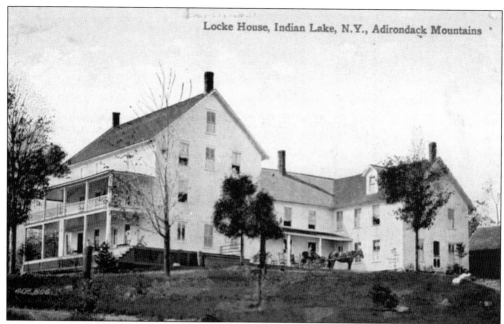

Pictured at the old Locke House is a horse and buggy waiting at the side door. This porch area was the owner's entrance to this lovely old hotel. In the scene below, the maples have matured, a sign has been added, and flower pots adorn the lawn, but this is still unmistakably the beautiful Locke House in Sabael. Several times during its history, the name of the hotel was changed. Nameplates such as Hotel Sabael and Indian Lake Lodge were hung above its main entrance. During the mid-20th century, the Locke House was again sold and was renamed the Air-O-Tel. In 1962, the hotel burned and was never rebuilt.

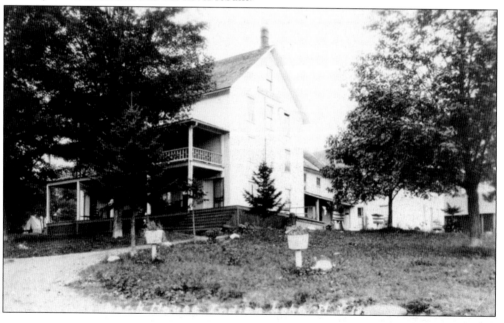

Across the old Sabael Road from the dance hall of Nathaniel Locke was a complex of camps. They were originally built near the ledges on the western shore of Indian Lake and were known as Pelon's Camps. These camps later became the resort called Camp Driftwood. A large home and other structures were built on the site, and other neighborhood properties such as the home of James Miller were absorbed into the complex. The individual camps are now named after Adirondack trees; one example is Camp Balsam. Today the beautiful Camp Driftwood resort, which still includes the original Pelon buildings, is owned and operated by Nicholas and Doris Voorhees and their son Jon.

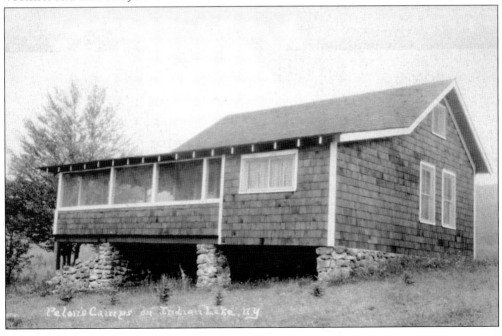

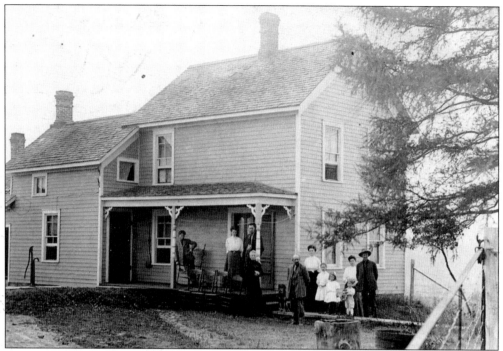

This boardinghouse, built on Christian Hill south of the village of Indian Lake, was owned and operated by Emma (Camp) Mead. Mead, wearing the long black dress, is standing on the ground in front of the porch pillar. She decreed that at her death (1934) the boardinghouse was to be given to her brother Gabriel Camp. Camp is pictured standing at far left on the porch.

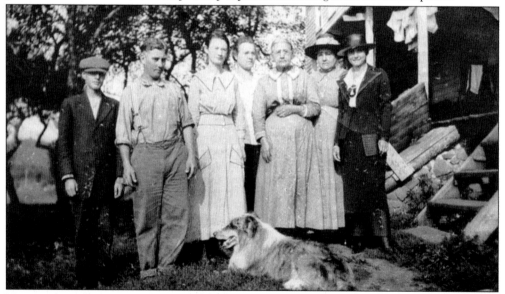

Next to the cellar stairs at the Adirondack Boarding House of Emma (Camp) Mead is Mead's brother Gabriel Camp (second from left with suspenders). He continued the business and farmed the land until his death in 1946. Standing to the left of Camp is his wife, Elsie (Corscadden) Camp Conklin, and her family members. She married Harold E. Conklin after Gabriel's death. Elsie died in 1959.

Six

WEST ON ROUTE 28

Route 30 north from Speculator intersects with Route 28 at Indian Lake's Main Street. Here a choice is made—left or right, east or west, Blue Mountain Lake or North Creek. A left turn at the intersection used to lead to an old dirt road bearing right across from the school. It was a well-traveled road, as it had a dual purpose. At about the half-mile mark, the road forked, and one branch went to the town dump. The dump was a very popular place for locals as well as tourists. The main feature was the black bears pawing through the garbage deposited on this site by the townspeople. Every night the bears came out to feed, and every night the people went to watch.

The other branch of the road went to the popular Old Swimming Hole that opened in 1938. This area served as the town beach for years until the new beach on Chain Lakes Road opened. The Old Swimming Hole was known for its cool freshwater springs and drop-off near the ledges on the Cedar River. If one were to travel farther west on Routes 28 and 30, one would pass the Cedar River House followed by the Cedar River Cemetery. This was one of the earliest burial sites in the town. The road to the left of the cemetery follows the original pathway taken by William Wakeley. Here is where Wakeley forged his way to the Headquarters Flow and built his Cedar River Falls Hotel.

This photograph of the Old Swimming Hole was taken on May 8, 1945. It is easy to see why this location was so attractive to tourists and locals. The picture must have been taken during the early morning hours, as this beach area was usually crowded with people of all ages. This beach was not just for swimming and sunbathing. At times, one might find swimmers in the middle and fishermen at both ends of the drop-off area, as the Cedar River was known for its native brook trout, bullheads, and rock bass. Although a seemingly peaceful spot, swimmers were always warned to be cautious of the undertow current near the ledges on the farther side. Many near catastrophes happened in this area. The mountain range along the Cedar River was adorned with native black and blue spruce trees.

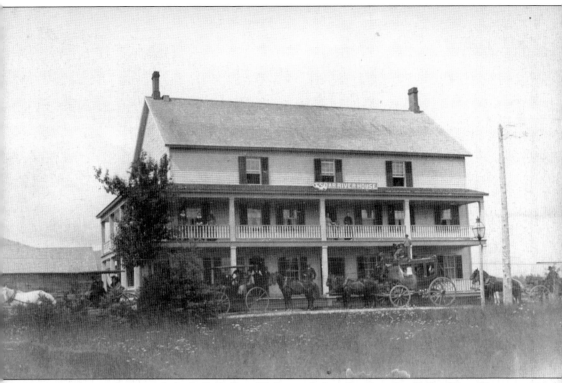

This is a cabinet photograph by J. F. Holly of Schroon Lake, showing the Cedar River House with several guests exiting after a function at the hotel. Pictured are buggies, carriages, and one of the major stagecoaches that ran from North Creek to Indian Lake and Blue Mountain Lake. On this particular day, all transportation seemed to be headed for the town of Indian Lake. The lack of mature trees, the telegraph pole standing next to the porch, and the oil lamp post on the front lawn would indicate that this picture was taken just after the name was changed from the Arctic Hotel to the Cedar River House. As with many of the old hotels, the Cedar River House was razed, and a small, modern one-story clubhouse was erected on this historic site. The Cedar River Golf Course is currently owned and operated by Anna and Peter Goldblatt.

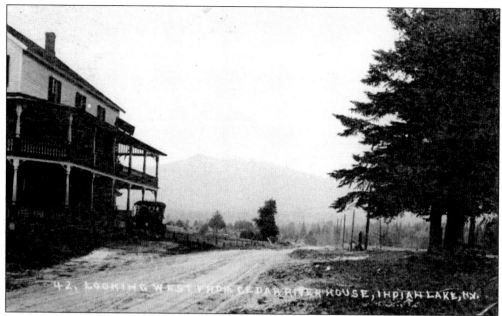

This is another view of the Cedar River House. It was built about 1863 by Richard Jackson and was originally known as the Arctic Hotel. Other owners of the hotel were B. Wadell, G. Scarrit, O. Cowles, F. Wood, and W. Goulet. Goulet sold the establishment to Dewey Brown, who for years ran the bottom floor of the hotel as the clubhouse for the nine-hole Cedar River Golf Course.

During the 1870s, William Wakeley built his Cedar River Falls Hotel on the Cedar River southwest of the village. However, the impressive three-story structure was destroyed by fire. Wakeley rebuilt the hotel only to see it burn again. Determined to succeed, Wakeley rebuilt for a third time but was forced to sell to the Finch Pruyn Company. While owned by Finch Pruyn, this hotel was managed by Frank Pelon.

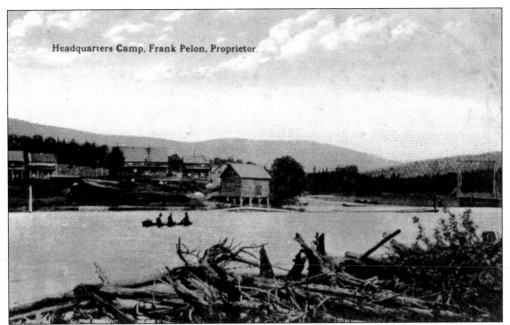

Headquarters Camp, Frank Pelon, Proprietor.

It certainly must have been difficult for Wakeley to sell this beautiful place (above) after the years of hard work and dedication to succeed. He had cut a road, built a dam, and set up his own sawmill in order to build the hotel. As fate seemed to dictate, after Frank Pelon assumed managerial duties of the Cedar River Falls Hotel, it burned for a third time and was never rebuilt. The Cedar River Flow, once a major logging waterway, is shown below flowing past the Finch Pruyn Company's original headquarters camp. Today this spot is the entrance to the Moose River Recreation Area, maintained by the Department of Environmental Conservation.

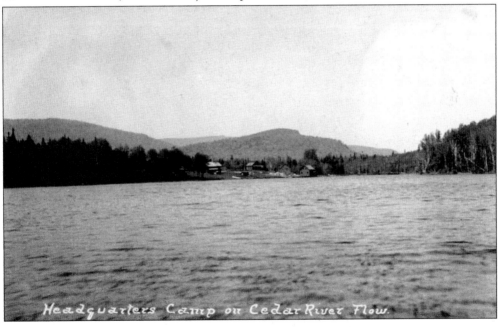

Headquarters Camp on Cedar River Flow.

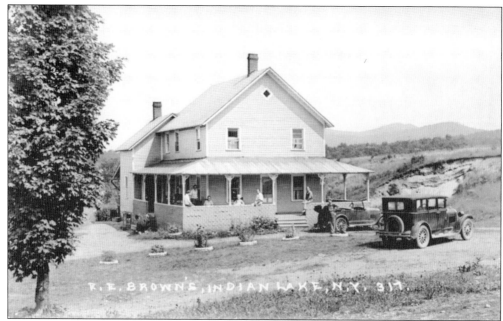

Ernest (Ernie) E. Brown and his wife, Elizabeth (Ovitt) Brown operated a small boardinghouse and cabins for tourists, fishermen, and hunters on Cedar River Road, south-southwest of the village of Indian Lake. Ernie, a World War I veteran, was listed with some of the first draftees from Hamilton County for the World War I induction in 1917. His name, along with 37 other World War I veterans from Indian Lake, is inscribed on the veterans' memorial monument. He was born on September 24, 1891, and died on November 20, 1969. Elizabeth was born on September 19, 1895, and died on August 28, 1974. Peaceful is the best way to describe their small boardinghouse on Cedar River Road. The campers and tourists appear to be enjoying the afternoon sun at the house and cabins.

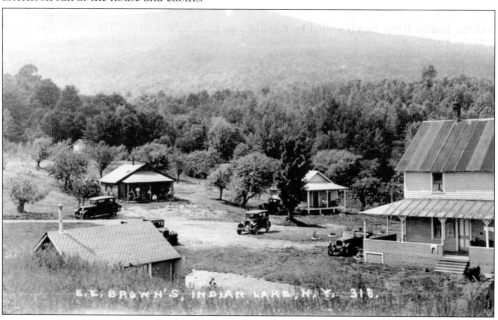

Seven

EAST ON ROUTE 28

If one took a right at the main intersection in town and headed east-southeast on Route 28, one would encounter a small body of water named Lake Byron. In 1931, a dam was completed at the end of Lake Byron, flooding town lands, homes, and some existing roads north and east of the village of Indian Lake. Later the town voted to rename the body of water Lake Adirondack. Continuing farther to the southeast stood yet another old landmark, named the Indian River Hotel. At the foot of the hill below the Indian River Hotel, just before the Indian River, which became Lake Abanakee, was another dirt road to the left, called Chain Lakes Road. The road followed along a narrow pathway of bends and knolls, ruts, and raised stones and carefully chased the flow of the Indian River until the first of the Gooley Club Camps was reached. This camp was later (1930s–1940s) known as the Main House at Hutchins on Indian River in Indian Lake. Here the border of Hamilton County was crossed and Essex County began as the Indian River became the border. At this point, Chain Lakes Road turned into Gooley Club Road, and the Indian River rapids ended by flowing into the Hudson River. Thus far, about three miles had been traversed. Another five to six miles of torturous travel and the third lake of the Essex Chain of Lakes came into view. This was where the Chain Lakes Sportsman's Camp was built. Originally this trip was made on the seat of a buckboard wagon being pulled by a team of horses. This is how people of the late 19th and early 20th centuries were transported to this remote location.

Leaving the village of Indian Lake and following the path of the old buckboards and stagecoaches that traveled to North Creek, many of the landmarks that made this area unequaled are now just a memory. The first such landmark was Lake Byron. This waterway was flooded and several acres of land were covered to create yet another recreational magnet for tourism. It is now named Adirondack Lake. Farther south was the Indian River Hotel, built in the 1860s by Milo Washburn, the owner of the sawmill in Big Brook. The technique used to build this hotel was very unique. It was constructed with 2-inch-by-6-inch-by-12-foot rough-cut planks, piled face to face on top of one another. Hundreds of feet of lumber were used in its construction, but Washburn owned his own sawmill.

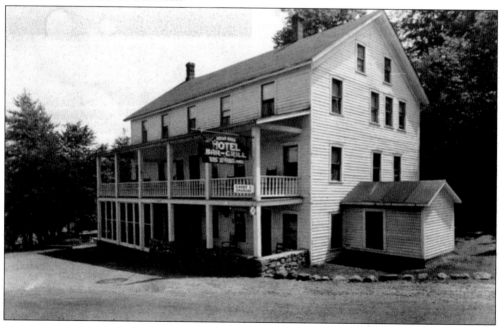

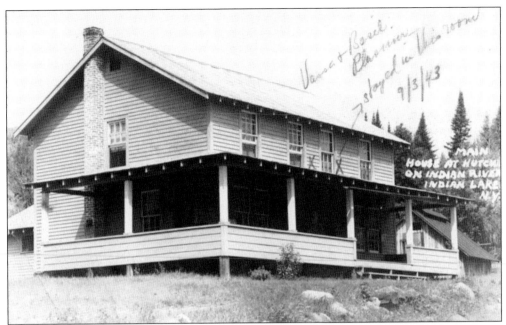

This was the lodge at the Indian Lake entrance to Chain Lakes. It was known in the 1930s and 1940s as the Main House at Hutchins on Indian River in Indian Lake. During the 1940s, this lodge was managed by Oliver Hutchins, the eighth child of Arvin and Ester (Lanphear) Hutchins, and Oliver's wife, LaVina (Savarie) Hutchins. Later the lodge was managed by another child of Arvin and Ester, Lois (Hutchins) King, and her husband, Lester P. King. Pictured to the right are Oliver, who was born on June 4, 1886, and died on April 30, 1950, and his wife, LaVina, who was born on October 25, 1891, and died on March 4, 1972.

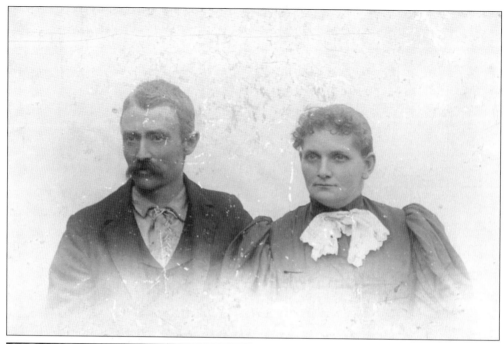

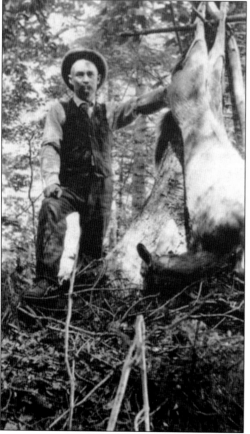

On the southeast shore of the third lake of the Essex Chain of Lakes, Arvin and Ester (Lanphear) Hutchins built their Chain Lakes Sportsman's Camp in the 1890s. The camp consisted of a main lodge and at least three smaller cabins, all built of logs from trees cut in the area of the lakes. Business was booming at the camp for the Hutchinses. At the same time, the two managed success in another aspect of life by having 16 children. The image above depicts Arvin, who was born on July 2, 1851, and died on October 20, 1932, and his wife, Ester, who was born in January 1858 and died on June 25, 1901. Arvin kept busy supplying food for the camp and his large family. The picture to the left is marked, "Arvin Hutchins—Violating."

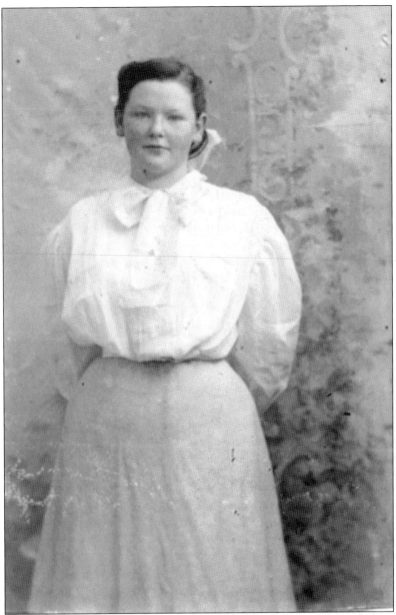

Elizabeth Marie (Hutchins) Lanphear McCane, the 11th Hutchins child, who was born on February 27, 1892, and died on November 4, 1974, is pictured at age 16 in 1908. Elizabeth left the camp at about age eight to work elsewhere. She became a house worker for a couple who lived in the village of Johnsburg. The family for whom she worked always smashed all waste glass, believing space would be saved at the dump site. One morning while taking the glass to the dump, Elizabeth cut her hand in the area of her ring finger. Throughout her life, her ring finger was very sensitive. She was always twisting and turning her rings around the finger area under her rings. One evening, while playing cards with her grandson, a small, round, smooth piece of green canning-jar glass worked its way out of her finger. She believed the piece of glass was from the childhood experience of cutting her finger at the dump site 70 years earlier. Her finger never bothered her again.

Pictured in 1899 in front of the third lake of the Essex Chain of Lakes are 7 of the 16 Hutchins children. They are, from left to right, Martha, age 6; Horace, age 3; Elizabeth, age 7; Clara, age 9; Lois (in Clara's arms), age 1; Carl (kneeling), age 12; and Francis (on Carl's knee), age 2. All of the Hutchins children were assigned daily chores to assist with the workload of their parents. Many times, the number of table settings needed just to feed the Hutchins family and the little hired help that Arvin Hutchins could afford was 26 to 28 places. This did not count the table settings for the tourists. Help from the children was needed. The chores included washing dishes, doing the laundry, cleaning the cabins, carrying water, picking berries, and attending to the livestock. It was not often that this many of the children had time to have their picture taken together.

William (Willie) Hutchins, the oldest of the 16 Hutchins children, was born on August 23, 1874, and died on April 10, 1902. He is pictured with his wife, Anna "Nan" (Eldridge) Hutchins, at the Chain Lakes Sportsman's Camp. Notice the buckboard wagons in the background that Arvin used to transport guests to and from the village of Indian Lake. This image was taken during the 1890s. The descendants from this one family produced and continue to produce many of the populace in the town of Indian Lake. Willie's siblings and their spouses included Agness and Henry Moulton, Ethel and Edmond Lanphear, Eva and Robert Blanchard, George and Suzie (Bennett) Hutchins, Addie and Melvin Lanphear, Kathleen (died young), Oliver and LaVina (Savarie) Hutchins, Carl and Lucie (St. Onge) Hutchins, Minnie (Bennett) Hutchins, Clara and John McCane, Elizabeth and Melvin Lanphear, William McCane, Martha and Wade Roberts, Horace and Mary (King) Hutchins, Francis (died young), Lois and Lester P. King, and Roland Hutchins. The genealogy of this family is deeply rooted in the history of Hamilton County.

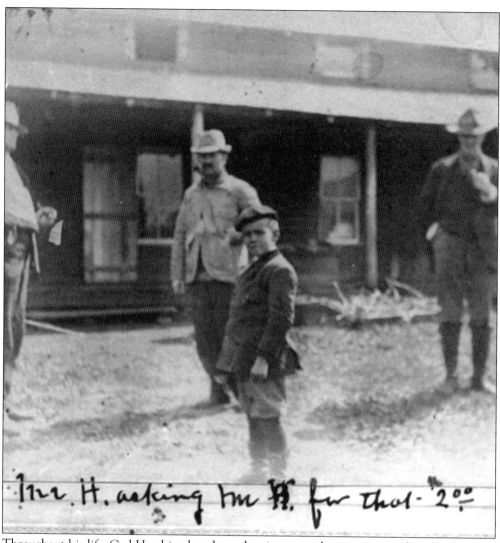

Mr H. asking Mr H. for that - $2.00

Throughout his life, Carl Hutchins loved to take pictures and, even more so, loved to have his photograph taken. Carl, the ninth child of Arvin and Ester Hutchins, is standing in the center, with Arvin directly behind him. On the left stands Henry (Hank) Moulton, who was Arvin's son-in-law. The man on the far right is unidentified. The caption written at the bottom of this late-1800s picture reads, "Mr H. asking Mr H. for that $2.00." The scene is in front of one of the buildings at the Chain Lakes Sportsman's Camp, where Carl spent his childhood. Even with all the assigned chores, the children did find some time to play. One favorite pastime was to seek out the large snapping turtles that roamed the area of the lakes. Upon finding the large beasts onshore, the game was to mount and ride them. It was said that Carl, or "Squeaky" as his siblings called him during his childhood, was the champion rider. Second place went to visiting cousin Arvin Moulton, who was the son of Hank and Agness (Hutchins) Moulton. Carl Hutchins died in 1980.

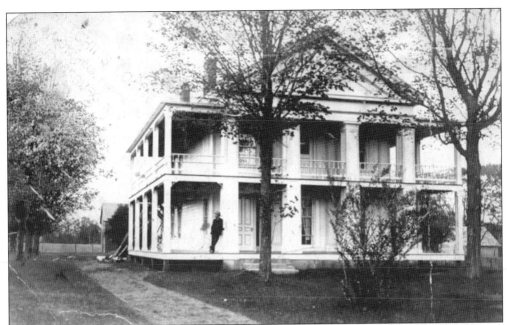

After several years and his wife's untimely death in 1901, Arvin Hutchins left Chain Lakes Sportsman's Camp and managed a hotel named the Hutchins Lodge in Johnsburg. At this time, the 16 children of Arvin and the late Ester were working, married, or living with other family members in the area of Indian Lake. The Chain Lakes Sportsman's Camp and the surrounding lands were sold into private ownership. The Hutchins Lodge was a stately, whitewashed building with large, formidable pillars. Arvin, in one of his natural poses, is seen above on the porch of the lodge around 1910. The picture below is the same Hutchins Lodge as it stands today on South Johnsburg Road. It was recently purchased for renovation.

Gently but proudly holding her infant brother Roland Hutchins is Ethel Hutchins, the third child born to Arvin and Ester Hutchins. Ethel and her husband, Edmond Lanphear, assumed responsibility of Roland after Ethel's mother, Ester, died in 1901. Ethel, born on March 15, 1878, died on December 23, 1954. Roland, her youngest brother, born on April 23, 1901, was two months old in this picture and died on April 19, 1926.

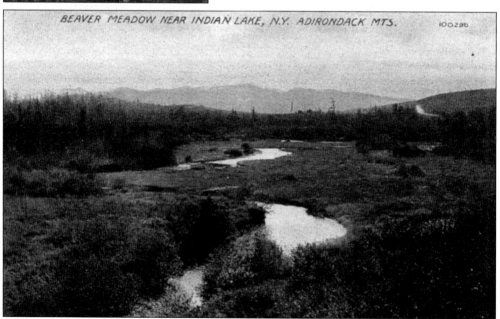

Continuing east-southeast from the village, one will soon reach a wet flatland known as Beaver Meadow. The Beaver Meadow Brook crosses Route 28 running southwest through the area known as Parkerville and flows into Lake Abanakee south of the village. This was also a favorite pathway used by the earliest settlers to get to Parkerville, Little Canada, Big Brook, and the eastern shore of Indian Lake.

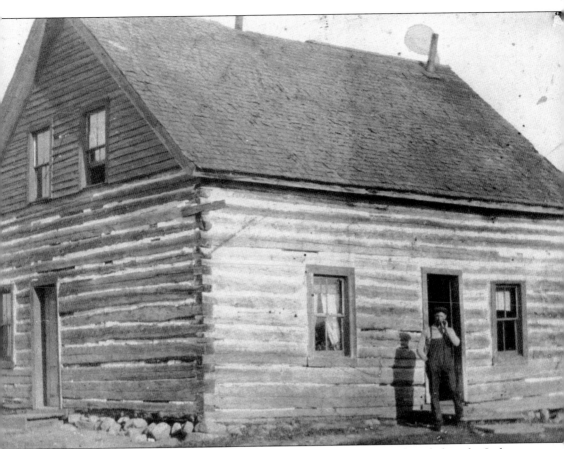

Thomas Fagan, who was born in 1851 in Ireland, came to America and settled in the Indian Lake area. Here he met and married Mary Bell, daughter of Hiram Bell, who was the first shingle maker in the town of Indian Lake. The Fagans fell in love with a section of land east of the village of Indian Lake a few miles east-northeast of the Beaver Meadow Flats. On this site, near a small body of water, Thomas built this log cabin at the foot of an Adirondack mountain. The areas later became known as Bell Pond and Bell Mountain. Mary gave birth to 16 children in this old log cabin. A few years later, Thomas purchased the larger Tucker Farm on Indian Lake–North River Road east of the Beaver Meadow Flats. Thomas and Mary (Bell) Fagan lived on the Tucker Farm until their deaths in 1898 and 1931, respectively.

During the early 1900s, Indian Lake–North River Road became one of the most dangerous roads to travel. The problem was a section of the road surrounded by land belonging to the Town of Indian Lake was owned by the Town of Minerva, and this stretch of road was not kept in usable condition. Thus, on May 24, 1915, a land exchange between Indian Lake and Minerva was negotiated. Indian Lake received the land containing the section of road in question, and Minerva received a parcel of land northeast of the village of Indian Lake. The Tucker Farm, located on the Beaver Meadow Flats, was part of the exchanged land given to the Town of Indian Lake. Purchased from the Tucker family by Thomas and Mary Fagan, and then by James and Nancy Fagan, the area is now called Fagan's Flats. Here James opened a small gas station on Route 28 with Nancy continuing the business years after the death of her husband. Eventually, before Nancy's death in 1987, the station was torn down for a road expansion project.

Eight

INDIAN LAKE
CENTRAL SCHOOLS

The first schoolhouse in the village of Indian Lake was built around 1878. It was a one-room building located about where the present high school stands today and was used until 1893. Then a new two-room schoolhouse was built on the same site. The first high school building in Indian Lake was completed in 1905 and graduated its first class of five students in 1908. The students were Charles Carroll, Guy Wood, Nina Ste. Marie, Katherine Persons, and Edwina Wilson. According to school records, there were no graduates in the years 1909 and 1924. The school boasted only one graduate in the years 1910, 1920, 1922, 1926, and 1927. Despite low numbers of graduates during these early years, advanced study by alumni was high. For example, records from the *1914 Catalogue of Indian Lake High School* list the alumni from 1908 through 1913. Of the 22 alumni listed for those years, 14 attended colleges or universities after graduation from Indian Lake High School. However, this high school building was destroyed by fire in 1921. In the meantime, schools were built in District No. 2 (Big Brook) around 1867, District No. 4 (Sabael) around 1869, and District No. 3 (Christian Hill, south of the village) around 1874. The present brick building housing the high school in the village of Indian Lake was completed in 1929. When the new school building opened, James Beha was acting principal. Beha continued in this position until 1936, at which time Milton S. Pope assumed the leadership role, a position that he held until February 1, 1972.

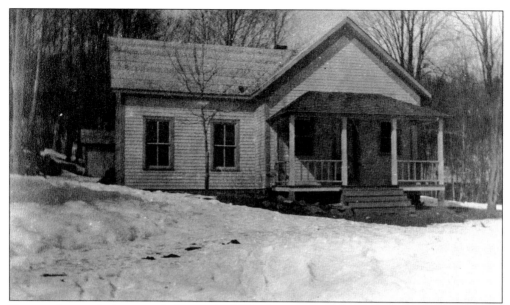

To meet the population growth during the 1870s, the people in the village of Indian Lake found it necessary to build a new school to facilitate the education of their children. The same was true with the outlying areas such as Sabael and Big Brook. Pictured above is the school constructed in Sabael around 1869. It was known as District No. 4 School and was located north of the Indian Lake House. The image below is of the schoolhouse built on Christian Hill. It was known as District No. 3 School and was built around 1874 at the summit of Christian Hill south of the village. (Courtesy of the Town of Indian Lake Museum.)

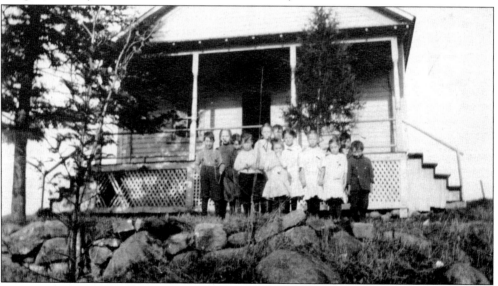

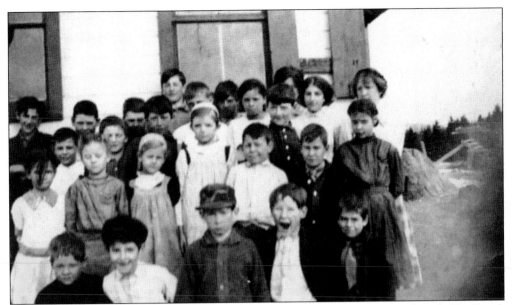

These smiling children, photographed around 1913 or 1914, are students attending the Big Brook School No. 2. The school was at the corner of Big Brook Road and Starbuck Road next to the Center Brook Bridge. Later the old school building became an Adirondack pine furniture plant owned and operated by local Big Brook resident Vivan King.

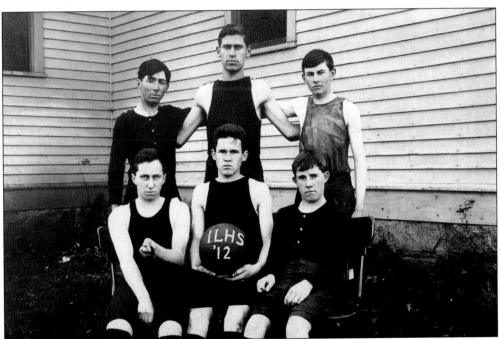

These "serious" athletes are members of the 1912 Indian Lake High School basketball team. They are, from left to right, (first row) Frank Brooks, William Hickey, and Archie Tucker; (second row) manager Frank McGinn, George Washburn, and team captain Harold Houghton. All players graduated during the years 1913 through 1915. (Courtesy of the Town of Indian Lake Museum.)

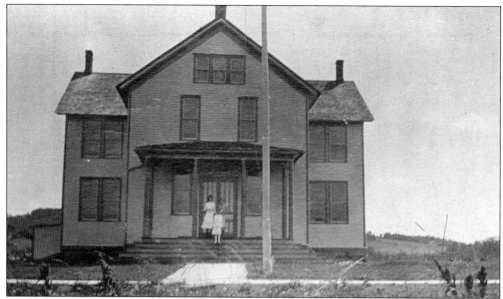

This was the first high school building at Indian Lake, completed in 1905 and destroyed by fire in 1921. Before the fire, this building served the faculty and students as one of the greatest learning centers in the town's history. During those 16 years, 13 classes totaling 49 students graduated in all. Because the fire totally destroyed the building, the 1921 graduation ceremony was held at Pelon's Dance Hall on Main Street. The senior graduating class in that year consisted of Dorothy Evans, Milton Carroll, and Donald McGinn. Pictured on the steps of the high school building, around 1914, are fifth-grade students Hazel and Teresa Hunt, and fourth grader Lucy King. In the image below, all students and faculty had gathered on the steps for this photograph opportunity from 1909 or 1910. (Above, courtesy of the Town of Indian Lake Museum.)

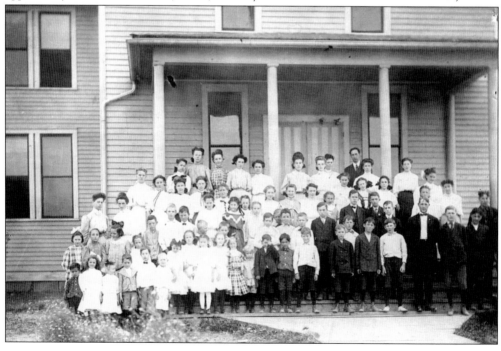

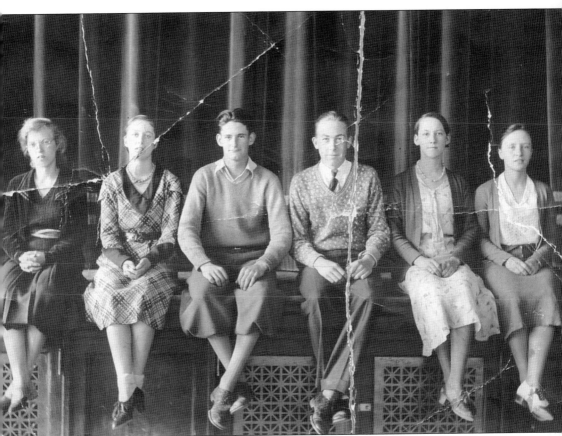

Seated on the auditorium stage floor of the present high school building are members of the 1932 graduating class at Indian Lake. They are, from left to right, Leona Spring, Louise Schloope, Grover Wilson, Ned Locke, Nellie Lanphear, and Marie Severie. This was a very close-knit group, as was attested to in the April 1932 issue of the school newspaper, the *Warrior*. The write-up featured an article titled "A Diary of One of the Seniors—Kept on the Trip to New York." The article tells of the good, clean fun a group of six youngsters and two adult chaperones had on a five-day trip from Indian Lake to New York City in March 1932.

Born in 1894, Hubert F. Carroll dedicated his life to practicing medicine in the town of Indian Lake. Upon graduating from the first Indian Lake High School building in 1912, Carroll attended Albany Medical School, later to return to Indian Lake as town physician in 1921. The town's health center is named after him. He was one of the more successful alumni of Indian Lake High School from this period.

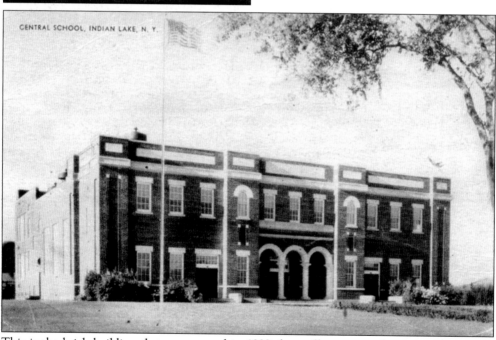

This is the brick building that was erected in 1929 that still serves as the present-day school facility at Indian Lake. It houses students from Indian Lake, Blue Mountain Lake, and Raquette Lake. Total enrollment in this building as of the 2006–2007 school year was approximately 198 students for kindergarten through grade 12.

Nine

OLD-TIMERS FROM INDIAN LAKE

Many old-timers in the town of Indian Lake were characters. They were individuals with unique qualities, qualities that helped make the town of Indian Lake successful. Many were not learned people by today's standards but were educated with basic common sense gained from the experience of "just plain hard work." Many were forced to leave school at an early age. Some worked in the lumberjack camps as a cook's helper or gofer or on the farms in support of their own families. Others were hired out as youngsters to work for other families as housemaids or chore boys. Stories are told that many children were only seven or eight years old when hired out to work away from their families. For many children, there was no time for schooling. Others started school but dropped out to work. Educations suffered, but practical experience was gained. Work was the teacher for many youngsters and adults. The old-timers loved their town, neighbors, and country. Above all, they loved their families, even though they were often separated from them. There were farmers, lumberjacks, merchants, doctors, teachers, housewives, and hermits all making up the township of Indian Lake. Families were big, and family reunions were common. These people's names were not printed in history books. They were plain hardworking folks. This is just a smattering of the great, unique but plain, old-time characters from the Indian Lake area.

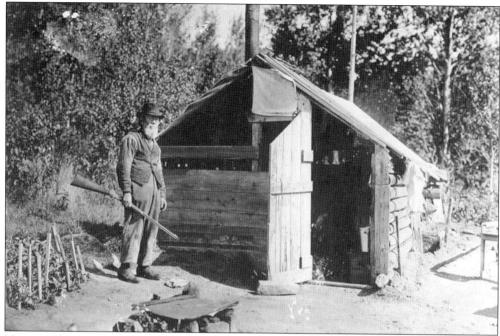

Norman Shaw was a hermit living on the eastern shore of Indian Lake during the late 1800s. Norman's Cove was named in his honor. Here he stands by his quaint cabin with his trusty rifle in hand. Also notice the little gardens to the right of Shaw. Many of the hermits kept pet snakes in their gardens and food barrels to keep insects under control.

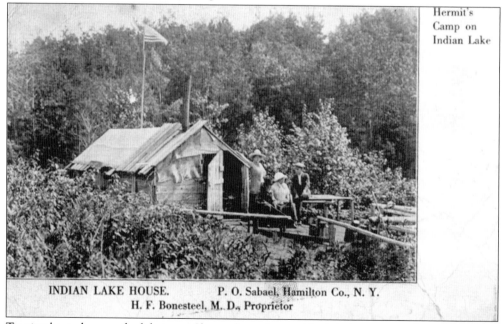

Hermit's Camp on Indian Lake

INDIAN LAKE HOUSE.　　　P. O. Sabael, Hamilton Co., N. Y.
H. F. Bonesteel, M. D., Proprietor

Tourists boated across the lake, gave Shaw a few coins, and had their pictures taken with the old hermit. During his last months, he was under the care of E. B. Aldons, the Indian Lake town overseer of the poor. It is believed that Shaw passed away on March 29, 1914, when payments to Aldons ceased. The cost to the town was $233.76 for this old-timer's care.

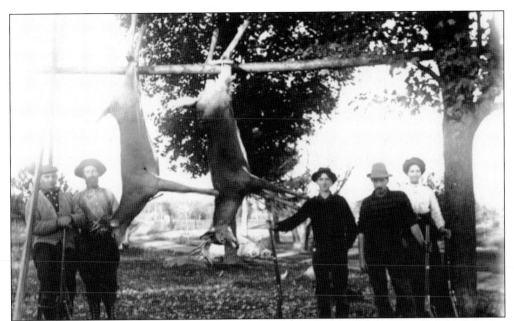

John (Jack) Burgess I was a hunter, guide, and proprietor of the Lewey Lake House. He also operated one of the largest maple syrup businesses in Hamilton County. He is pictured second from the left after a successful day's hunt. Also pictured are his son Eugene Burgess, known locally as Vinton, (second from right) and his daughter Eva Burgess (far right). The other two gentlemen are unidentified.

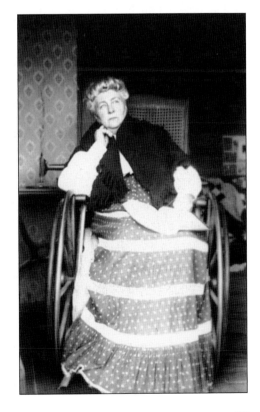

Mary (Lawrence) Burgess was born in Sabael on July 4, 1868, and died on June 28, 1911. Her parents, John Lawrence and Mary (Porter) Lawrence, came to Indian Lake from Crown Point and settled in Sabael during the mid-1800s. The younger Mary married John (Jack) Burgess I in 1886 and was confined to a wheelchair most of her life.

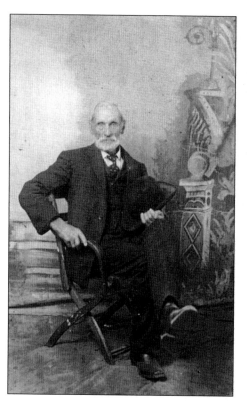

This proper-looking gentleman is George Wellington Lanphear, who was born in 1839 to parents Leander and Abigale (Parker) Lanphear. They had moved from Vermont to the Adirondack area to raise their eight children, including Lorinda, Albert, Sophronia, Henry, Sarah, George, Leander Jr., and Jane. George married local girl Emma Plue, who also gave birth to eight children, including Stillman, Celestia, George Jr., Delilah, Melvin, Harriet, Frederick, and Orrin.

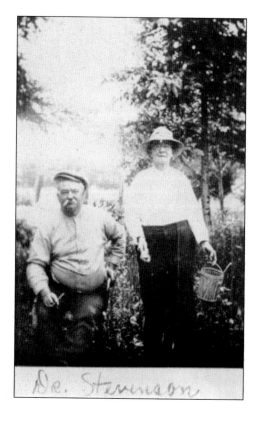

After studying medicine in Philadelphia, Frederick Stevenson moved to the mountains and became the Indian Lake town doctor, where he remained in practice until his death on March 7, 1928. During Stevenson's last few years, Dr. Howard Bonesteel and Dr. Hubert F. Carroll also opened medical practices in town. Pictured with Stevenson is his wife, Florence (Carlin) Stevenson. The Stevensons are buried in the Indian Lake Cemetery.

Darwin Parker, born in 1829, moved to Indian Lake from Queensbury and married local girl Sophronia Lanphear. The Parkers cleared and settled a piece of land east-southeast of the village of Indian Lake. After clearing the land in the 1850s, the area was named Parkerville in honor of Darwin Parker.

Meta McCane, born in 1869 in Minerva, married George McCane from Fort Ann and moved with him to Indian Lake. Here Meta gave birth to nine children, including William, John, Hazel, Fern, Alice, Harry, Ralph, Roger, and Frank. The McCanes worked faithfully for the First Baptist Church at Indian Lake and were instrumental in the building of the new Baptist church in the 1890s.

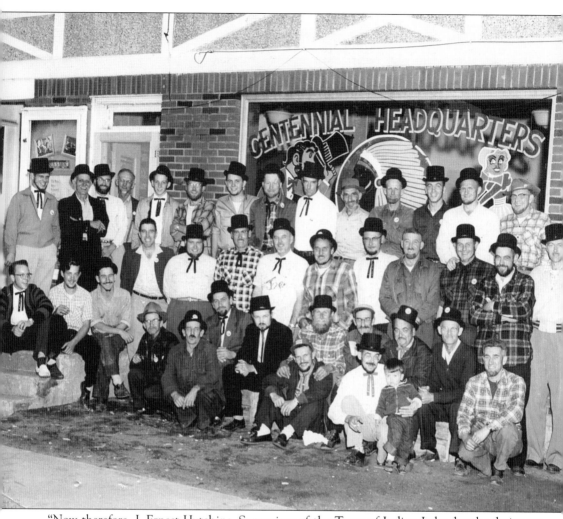

"Now therefore, I, Ernest Hutchins, Supervisor of the Town of Indian Lake, hereby designate August 8–11, 1958, as Centennial Days in the Town of Indian Lake, the culmination of months of planning and the finale of this summer's gala celebration. In Witness whereof, I have hereunto set my hand and caused the Seal of the Town of Indian Lake to be affixed. Done at the Town of Indian Lake the First Day of August in the Year of our Lord, Nineteen Hundred and Fifty-eight." This quotation by Ernest (Ernie) Hutchins (front row, second from right) ushered in Indian Lake's Centennial Days, during which, among other things, all local men who were able were to grow some type of facial hair or face a fine from the Brothers of the Brush Committee. Pictured are some of the town's men in front of centennial headquarters proudly displaying their beards.

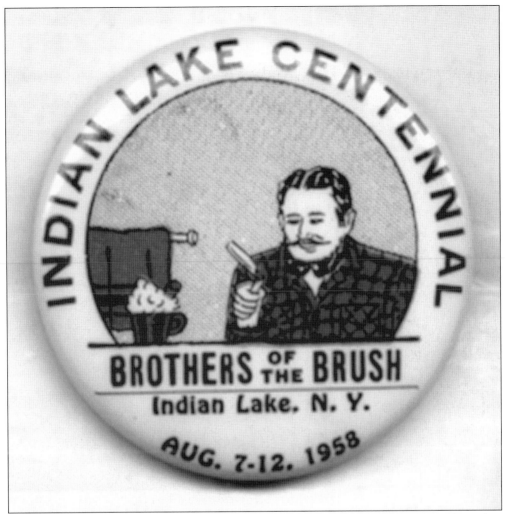

INDIAN LAKE CENTENNIAL

BROTHERS OF THE BRUSH

Indian Lake, N. Y.

AUG. 7-12, 1958

To prepare for the 1958 Centennial Days celebration in the town, committees were formed to share the gigantic workload presented by such an undertaking. Committees such as operating, construction, historical, parade, and revenue were named. There were also committees formed that were more caprice or whimsical in nature, such as the Brothers of the Brush Committee. The weeklong festivities created an atmosphere of fun and enjoyment, but many were surprised when they were tossed into the 1850s jail for not obeying the rules of the committee. Pictured is the Brothers of the Brush centennial pin.

Three families of Indian Lake are represented by the gentlemen pictured. Standing at left is Guy Fish, who graduated from Indian Lake Central School in 1911. Standing next to Fish is Andrew King. King graduated from Indian Lake in 1916. Both men were World War I veterans. Seated is William Bennett. All three were from large families whose members played leadership roles throughout the town's history.

George Virgil was the son of Ernest and Zilda Virgil. He was a World War I veteran, and his name is inscribed on the monument in the town. He lived to be 99 years old. Pictured with him is his wife, Beatrice (Brown) Virgil. She was the daughter of Frank and Lena (Fish) Brown. Beatrice also lived to be 99 years old.

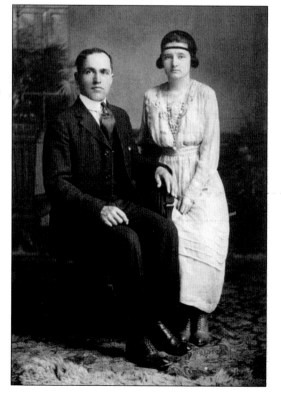

Pictured from left to right are Katherine (Persons) Early, Mary Louise Gill, unidentified, Elizabeth (Persons) Alexander, unidentified, and Lillian (Hall) McCane. Early graduated from Indian Lake schools in 1908 and from college at Geneseo State in 1910. She taught in New York State schools for 43 years, including 25 years at Indian Lake. She was the daughter of George Persons and Ida (Fish) Persons of Indian Lake. Gill was born on June 21, 1911, to Hartwell Gill and Julia (McGinn) Gill. She taught elementary education at Indian Lake for 37 years. Alexander graduated from Indian Lake High School in 1912 and from the Plattsburg Normal School in 1914. She was also a daughter of George Persons and Ida (Fish) Persons. McCane was born on January 9, 1884, to George B. Hall and Anise (Murray) Hall. She operated the Indian Lake switchboard in her home beginning in 1915. She was a great patriot and organizer of veterans' affairs.

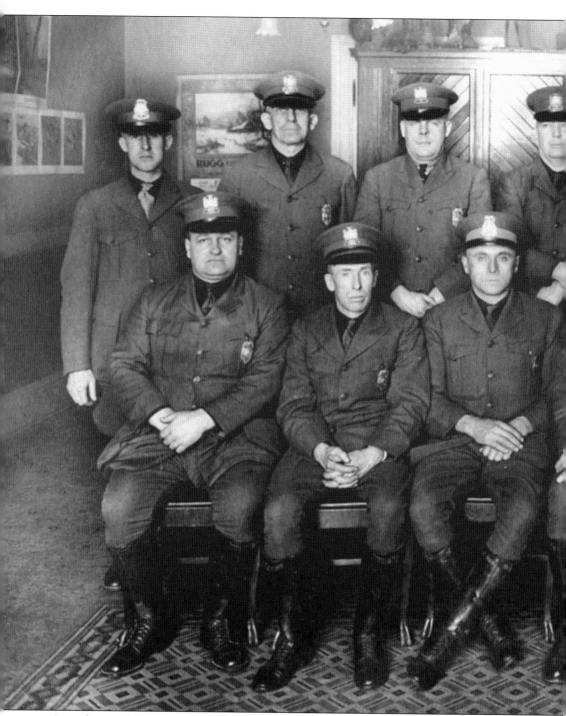

According to the Web page titled "R. B. Nichols, Game Warden, Indian Lake, 1910" that was created by Jim Claffee and William Zullo, Robert Burns Nichols moved to the mountains from Canada and married into the Brown family of Indian Lake. Here he became a game warden for the conservation department. A daughter, Estella, born to Nichols and his wife, Etta, married a local man, John (Jack) Farrell. After Nichols retired in 1926 from a position he had held for

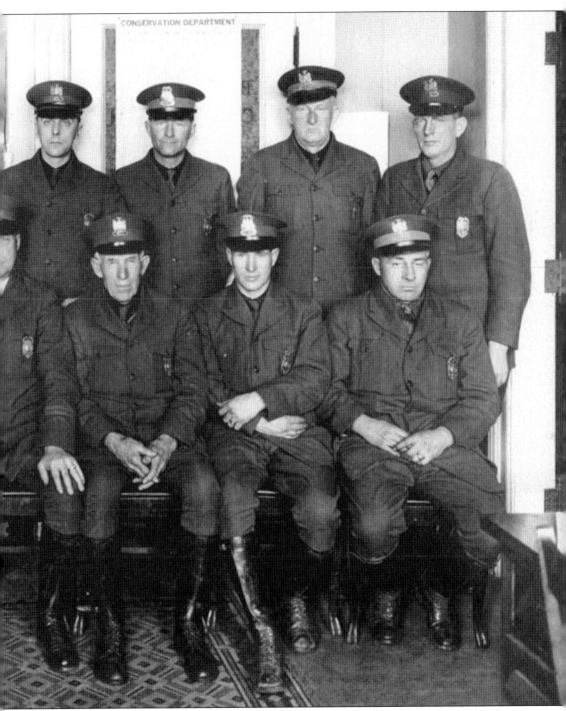

over 20 years, Farrell replaced his father-in-law as game warden for the region. He remained in this position for many years. Farrell stands at the far right of the back row in this photograph, taken in 1929. The picture, taken by H. W. Pangburn of Glens Falls, features game wardens of the Adirondack region during this era. Farrell died in 1946.

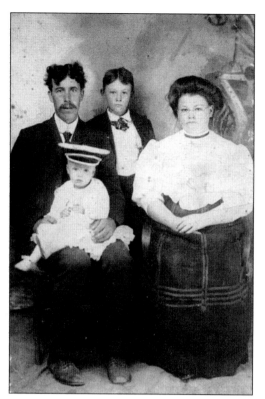

Robert (Rob) Blanchard and his wife, Eva (Hutchins) Blanchard, are pictured with their sons Clifford and Kenneth between 1906 and 1908. Eva, who was the fourth of 16 children born to Arvin and Ester Hutchins, also gave birth to a girl named Gladys. Robert was a well-known guide and carpenter and was responsible for the construction of several of the homes in the Big Brook area.

The Daniels family will always be remembered as living in the big yellow house next to the Big Brook School on Starbuck Road in Big Brook. Pictured from left to right are the Danielses' neighbor Isabelle (Porter) Blanchard, Josephine Daniels, Stafford Daniels, and Carrie Daniels (seated next to Blanchard). Carrie was the wife of well-known lumberjack Sidney (Sid) Daniels.

Mary (King) Hutchins is seen here with her boys around 1932. Pictured from left to right are Horace Jr.; Lester, the baby on Mary's lap; Herman, with his pants falling; and Sherald. Even though she was a busy housewife and mother of nine children, Mary still found time to electioneer for a local politician. The boys appear adorned with political pins on their shirts, but the names on the pins cannot be discerned.

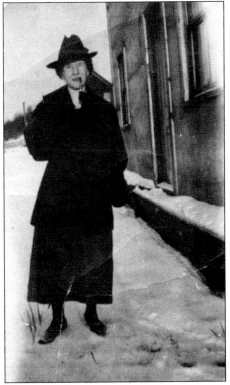

Nulia Myrtle (King) Campney was born on December 14, 1890, to Joe and Mary King of Big Brook. In this picture, taken outside the home of fellow Big Brooker Lizzie (King) Blanchard, Campney is proving that women during the early 1900s enjoyed the flavor of a good pipe as much as their husbands.

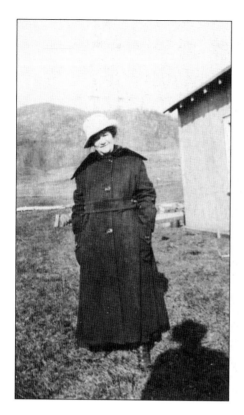

Pictured is Corey Ray, who was the wife of local Big Brook farmer Walter Ray. Together they owned and worked a section of farmland on the Indian River south of the village of Indian Lake. Much of this land was lost to flooding when the Indian River was dammed to create Lake Abanakee.

George Morehouse moved to Indian Lake from Johnsburgh during the later part of the 1800s. He is listed in the history books as a locksmith and mechanic. Morehouse also owned his own blacksmith shop in the village. He served as the Indian Lake School District No. 1 trustee in 1889 and was the town supervisor from 1905 to 1910. He is pictured with his wife, Mary (Morgan) Morehouse.

Abigal (Lanphear) McCormack, who was born in Whitehall, and her husband, Hugh, were among the first settlers in the Big Brook area. Here on the land near Center Brook, the McCormacks farmed and raised their family. Hugh, who was born in Clintonville, fought in the Civil War with Company E, 2nd Regiment Cavalry New York Volunteers. "Aunt Abby," as Abigal was known, was a loved and respected housewife and mother.

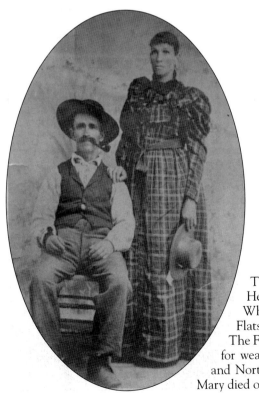

Thomas Fagan came to this country around 1870. Here he met and married local girl Mary Bell. While residing in the area of the Beaver Meadow Flats with Thomas, Mary gave birth to 16 children. The Fagan farm soon became a very popular stopover for weary folks traveling the road from Indian Lake and North River. Thomas died on December 6, 1898. Mary died on October 31, 1931.

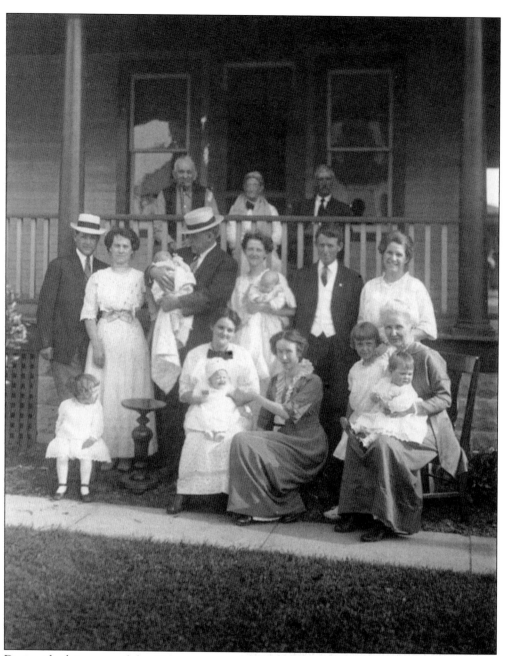

During the later part of the 19th century and into the early 20th century, Edward A. Wilson owned and operated a store on Main Street in Indian Lake with James McGinn. It was a huge wooden structure located directly north of the intersection of Routes 30 and 28 in the town. The store carried a general line of merchandise to meet the needs of the townspeople. In 1909, the store was purchased by local businessman H. A. Palmatier and continued to operate until it was destroyed in the fire of 1921. This is a photograph of the Wilson family around 1900. In this photograph, Wilson is seated at the far left on the porch with a cane in his hand. Martha, Wilson's wife, is seated at the bottom right, with a grandchild on her lap and another under her right arm. Others are unidentified family members.

Abraham King (seated below), who was born on July 30, 1872, and died on July 20, 1951, was first married to Zilda Virgil, who was born in 1867 and died on February 27, 1907. Together they had a son, Henry King, on May 7, 1902. After Zilda's death, Abraham married Lillian Plue, who was born in 1882 and died on February 24, 1955. Pictured to the left of Abraham is Mrs. Gideon Savarie, Lillian's mother. Henry is pictured sitting on Abraham's knee, and Lillian stands to the right of Abraham. The King family lived in and operated a small store east of town across from the dam at Lake Byron.

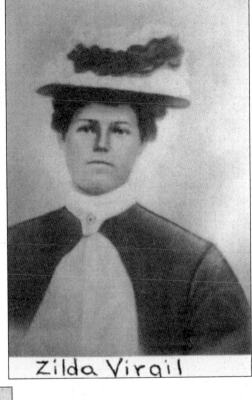

Zilda Virgil

Charlie St. Onge, or "Santos" as the French Canadians pronounced his name, came from Canada and settled with his siblings above the two bridges of Big Brook and Beaver Meadow Brook, where he worked the land as a farmer. Later this farmland area became the location of the Ernie Hutchins Saw Mill.

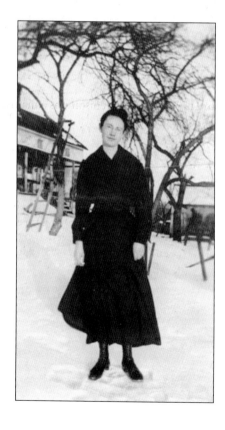

Elsie (Corscadden) Camp Conklin was proprietor of the Adirondack Boarding House, located on Christian Hill south of the village of Indian Lake. Conklin had assumed ownership after the death of her first husband, Gabriel Camp. She ran the boardinghouse with her second husband, Harold Conklin, until her death in 1959.

Ten

HARDWORKING PEOPLE

There was always work that had to be done. Many times during these early years, neighbors worked together, helping at barn raisings and house-raisings, with the slaughtering of livestock, and with haying, logging, clearing land, and cutting firewood. It was always comforting to know that one could count on a friend or a neighbor to help make the work more manageable.

Many jobs were time-consuming and difficult. Early lumbering was an example of real work. In the late 1800s, trees were tediously chopped with a double-bit ax. After a few years, the job was made much easier when lumberjacks began using the two-man crosscut saw. This invention allowed for partnerships between lumberjacks, which increased productivity, but the job remained extremely difficult. Lumbermen still depended on the ever-faithful horse to transport logs to the streams and lakes where they were floated to their next destination.

Hunting was a form of recreation for tourists, but for the locals, it was an indispensable job. Deer were hunted and sold to the hotels and resorts for their meat supplies. During the 1800s and into the 1900s, venison was a mainstay on menus offered at many of the major Adirondack resorts. Locals were hired as permanent hunting guides at these establishments. Venison was also needed to feed the local families, which sometimes extended to include in-laws and boarders. Hunting was work, and the game taken was the "fruit of the labor."

To be a good patriot was also hard work. A true patriot was one who loved, supported, and defended his or her country. To just say one was a patriot was easy, but to do the actual work to prove that one was patriotic was difficult. One of the greatest patriots of Indian Lake was Lillian (Hall) McCane. McCane began operating the town's switchboard from her own home in 1915 and served this function for several years. During this time, she focused much of her energy on supporting the military men and women. She gave countless hours to raise funds for the veterans of the community, honoring them with memorials and other projects.

Many times, a second layer of boards was added to a building, and straw was forced between the two layers for insulation. This helped keep animals warmer during the long, cold winters in the Adirondacks. Working to insulate this old shed are, from left to right, Horace Hutchins Sr., George Lanphear, and Robert Blanchard.

Using an old horse-drawn bucket scoop was real work. It guaranteed that the user's shoulders would ache for days. The dirt was scooped out as the horse slowly pulled the bucket along the ground. Then the bucket was dumped, and the stones were picked and piled. The horse was turned around and the process was repeated over and over. The picture is labeled "Indian Lake—1901."

104

Milford Benton was superintendent of highways for the town of Indian Lake. He held this elected position, faithfully serving the townspeople, for over 30 years. Benton married Lena Bennett, another lifelong resident of the town. In the scene below, dated April 18, 1945, Burt Parker, seated in the old Walter truck, has just returned to the town barn after grading down one of several dirt roads in the town of Indian Lake. Parker, one of the town crew, is talking to Charlie Carroll (left) and Melvin Lanphear. The roads were graded smooth, and salt was spread on the surface to control the dust.

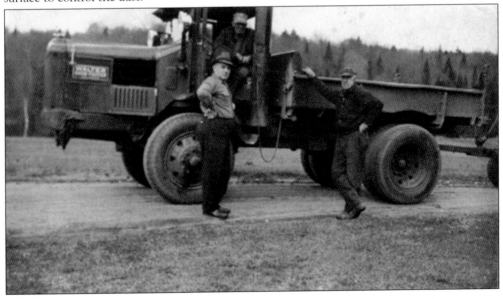

Gordon "Blackie" DeMarsh, who was born on October 16, 1908, and died on May 21, 1981, is pictured standing in front of his Big Brook barn with his prized horses Red (right) and Molly. The following is from an article written by Anne LaBastille titled "The Guide . . . Living Legend of the Adirondacks" from the winter 1972 issue of *Adirondack Life Magazine*: "Blackie had several teams of horses during his career as a lumberjack, but one in particular stands out. A big bay, 'Red,' weighing 1800 pounds, helped his owner with both logging and guiding. Known as the 'Pride of Big Brook,' the horse used to follow Blackie everywhere in the woods. It did not mind when a dead deer or two were tied against its sides. In fact, Red might even lick the blood off his skin! He was smart enough to gauge distances between trunks and never dislodged a deer. Blackie and Red spent 14 years together guiding and carrying for hunters."

Lucie St. Onge, ready to take her pack basket full of sap spouts to the maples, was also in charge of keeping the fire hot under the boiling sap. She boiled hundreds of gallons of sap to produce a few gallons of pure Adirondack maple syrup. St. Onge produced some of the finest syrup at her sugar bush located a few miles north of King's Flow in Big Brook.

This 1930s image proves how men working together could achieve great things. The story is told that in as few as three days, logs were cut on-site and this shed was erected at Gavett's Resort near Route 30 south of the village of Indian Lake. The shed was used as an automobile and storage shed.

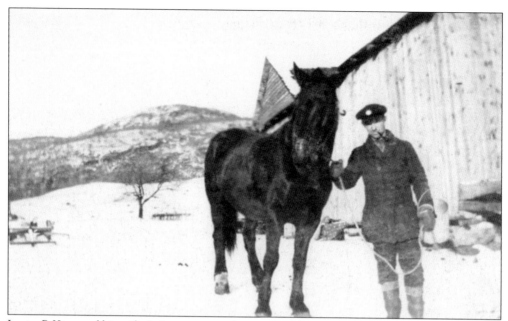

Lester P. King and his wife, Lois, were caretakers at the Chimney Mountain House resort. Lester, pictured with his horse, is preparing to haul firewood from Bullard Mountain. He would fill all the wood boxes at the main lodge and the surrounding camps from stockpiles of dry wood that were scattered along the mountainside.

Frederick (Fred) Lanphear appeared for this photograph dressed in his overalls, ready to shear the sheep. All the gear is accounted for, including wraps, two pairs of clippers, and an old whetstone used to keep the clippers sharp as razors. Lanphear spent the next few days preparing the wool for spinning.

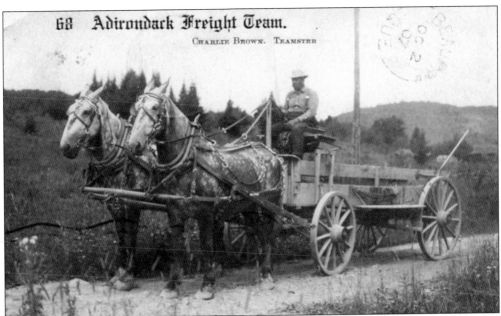

During the late 1800s, many buckboard teams for hire worked the small Adirondack communities. The 1900 Hamilton County census records show different individuals named Charles Brown listed in the towns of Arietta, Inlet, and Morehouse-Bethuneville, with two individuals listed in Lake Pleasant. It is unknown which Charlie Brown is pictured here. A beautiful and proud team of dapple grays is shown pulling Brown's old buckboard.

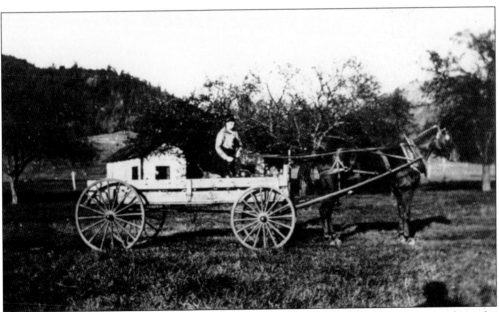

Lucie Hutchins is pictured here preparing to drive her horse and buckboard wagon from the Chimney Mountain House area in Big Brook to the village of Indian Lake for supplies. This trip was 14 miles one way and would take from dawn until dusk. Trips from Big Brook to Indian Lake were usually completed once a week.

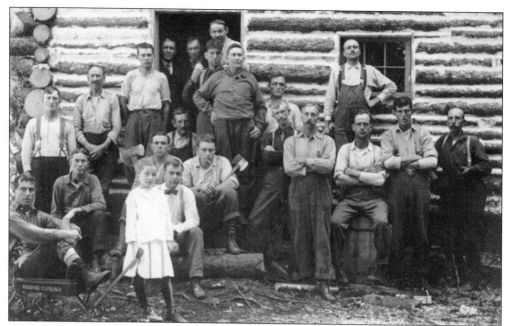

Sal Juckett, standing in front of the door with his hand on his hip, was the boss of the lumberjack camp at the mouth of the Indian River. He stands here with other loggers and river drivers from the Indian Lake area. Notice the men in front of Juckett proudly displaying their double-bit axes. It is said that some kept their axes sharp enough to shave their beards.

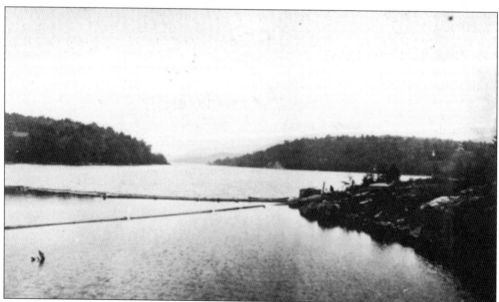

This boom was used to catch logs floated from the areas of the Jessup River and Lewey Lake. It was stretched across Indian Lake, where many of the logs were trapped and taken ashore for further transport to the nearby mills. Other logs were floated farther north into the Indian River and on to the Hudson River.

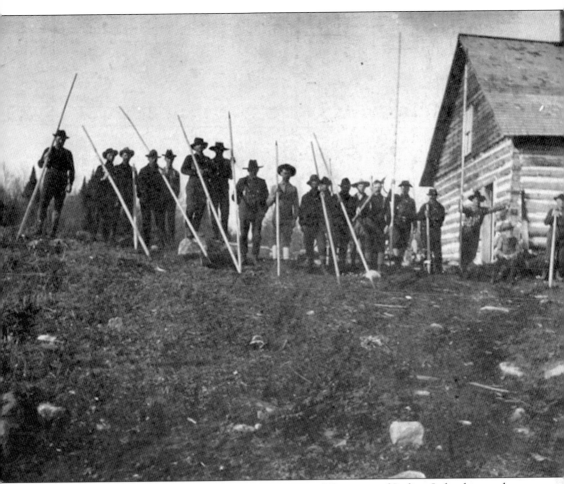

According to the late John Burgess, former supervisor of the town of Indian Lake, his mother, Margia (Starbuck) Burgess, was the cook at this camp at the mouth of the Indian River. In this late-1800s picture, 19 river drivers and log walkers, wielding their cant hooks, peaveys, and pike poles, were photographed waiting for a shipment of logs. These brave men walked the shores and rode the logs in the water and, with the use of their poles and hooks, kept the logs from jamming. The logs would arrive floating in the rapids of the Indian River, which flowed directly ahead of the lumberjacks in the photograph. At the center of the picture, eighth from the left, is George Springs, a local man who functioned as the river drive captain at this camp. The back of the photograph is marked "Margia Burgess—River drivers at the mouth of the Indian River."

Al Kimball's camp was located south of Farrington's Hotel, on the western shore of Indian Lake. This lumberjack camp featured the typical collection of pots, pans, and the "singing" tea kettle on the stove. Also note the lumberjack's socks, boots, and pants drying on the rod next to the stovepipe, from which most of the heat radiated. His shaving mirror hangs by the window.

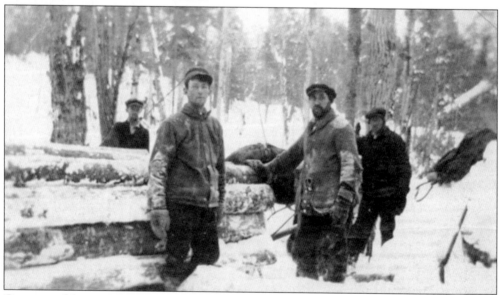

On a typical frosty, winter morning, this crew has the horse hitched and the load of logs on the bobsleds. The next stop was the header, where the logs were unloaded. The whole process was repeated again and again. Pictured from left to right are Horace Hutchins Sr., Arvin Moulton, and Melvin and Frederick (Fred) Lanphear.

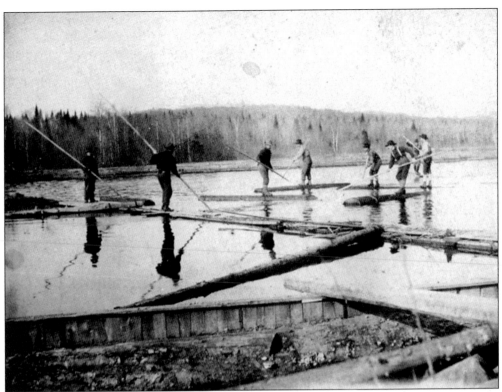

Above is a great early scene showing some of the river drivers using their pike poles and cant hooks to control the logs at the boom on the mouth of the Indian River, where the main lumberjack camp was located. Margia (Starbuck) Burgess was the cook at the camp and was known and appreciated for her hearty meals. It was said that the lumberjacks never left Burgess's table hungry. The scene below depicts another 1900s log boom across Indian Lake. Most logs at this time were caught at a boom near the "Jack Works" area on the western shore of Indian Lake.

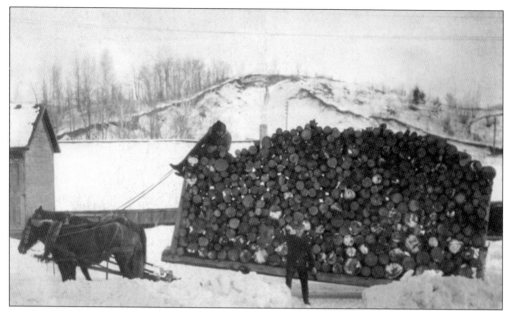

Some of the earliest lumbering in the area was done in the mountains and valleys around Lewey Lake. Working in this area were noted lumbermen George Griffin and Louis "French Louie" Seymour. The image above is a picture from Lewey Lake and shows bobsleds loaded with "four-foot," or pulpwood, being hauled to a header during wintertime conditions. The image below from Lewey Lake shows a loaded sled approaching a header area in early springtime. Lumbermen had used logs to bank the road. Banking helped to level the load and keep it from tipping. Roads were constructed down the mountainside in an S pattern to help control the descent of the heavy loads of logs or pulpwood.

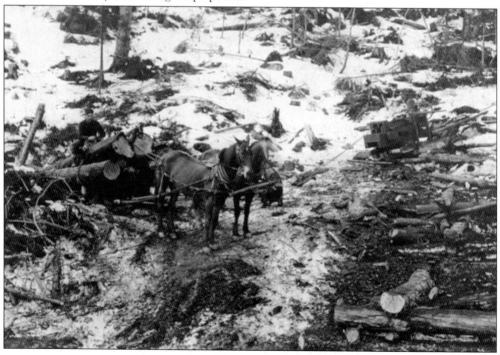

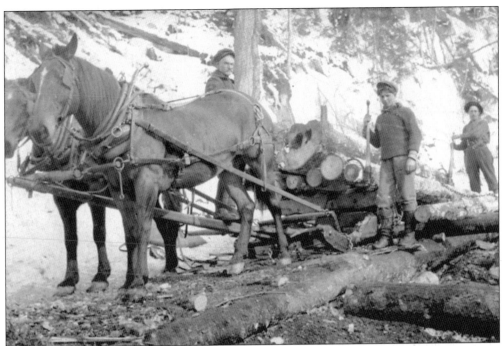

In this Lewey Lake lumbering postcard, three men are using peaveys to unload or roll logs onto a header. A peavey is a heavy oak-handled lever with a cant hook attachment. It was used to roll or move logs from one location to another. The peavey was invented by Joseph Peavey around 1872. The postcard below shows two horse-drawn bobsleds descending a treacherous slope on the mountainside. Even the horses have their brakes on. Notice the sapling binder used to hold the log chains tight to the sleds. Other logs can be seen on the mountainside behind the standing driver. These logs were all rolled and piled by hand with the use of a peavey.

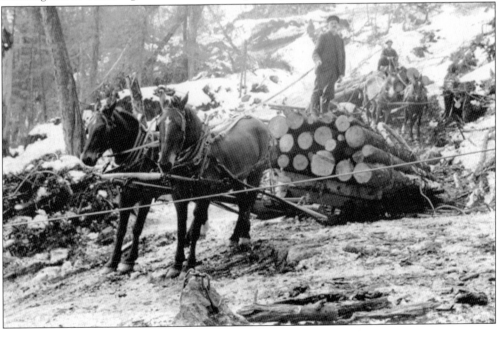

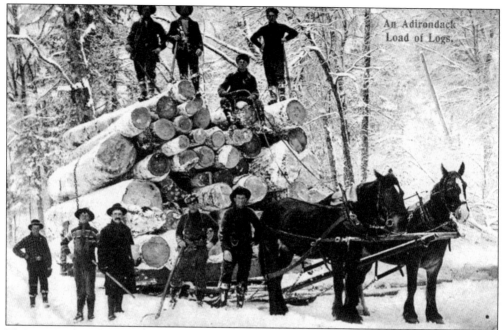

This was not a typical load of logs (above). Contests were held among lumber camps to see which could mount the biggest load. This was a very dangerous game and many times resulted in injury or death for men and horses. Even when the camps were not engaged in competition, injuries occurred, as many times during the process of loading, the cant hook on the peavey would slip causing the logs to roll back onto the lumberman's legs or body. The picture below is a load of logs that has reached the mill. Behind the load was the "marker," who would measure the logs before unloading. He also wielded a marking hammer that had the initials of the mill or cutter engraved in its iron head. He would strike the butt end of each log to initial ownership.

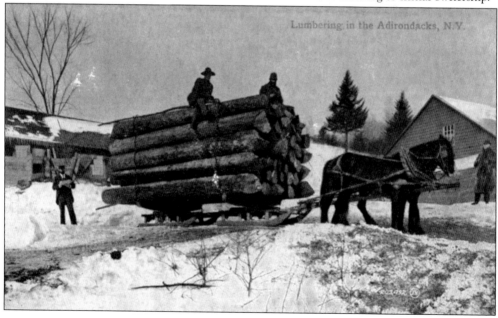

In 1907, a massive logjam occurred in North River. The jam started on the Hudson River and extended on to Route 28 just south of the Hamilton County line. Logs had been floated from the Indian River into the Hudson River and had been carried by the rapids of the river to this point. The scene below is also of the March 30, 1907, logjam. The building in the background is the North River Hotel that, for a time, was a favorite "meal-stopover" for weary stagecoach passengers using this much-traveled road. The ice jam took several days to clear.

The morning was cold, but these hunters are dressed and prepared for the day's challenge at the Cedars, the home of Harry and Amy (Van Dusen) McCane. Standing from left to right are William McCane, Roger McCane, Royce Wells, Harry McCane, and John McCane. The McCanes were all sons of George and Meta McCane of Indian Lake. Wells was a son-in-law of Harry. The McCanes knew the territory well and always got their deer. Harry and his wife, Amy, might have taken a second look out their kitchen window on this cool October morning in 1943. The following unique news item was in the local newspaper of the town of Wells in Hamilton County: "The hunting season began Sunday, Oct. 20, in an unusual way at the hunting lodge, 'The Cedars,' home of Mr. and Mrs. Harry McCane, of this village, when an airplane suddenly swooped down into the road near their barn and taxied towards the lodge. Mr. Stanley M. Glogowski of Troy had arrived for a few days of hunting in the Cedar River area."

This black bear was shot on one of the hunts at the Chimney Mountain House on Bullard Mountain during the 1941 hunting season. The trophy was hung in the old apple tree by the main lodge. The trash cans were then safe for a while, until another black bear sauntered from the woods to investigate the refuse at the resort.

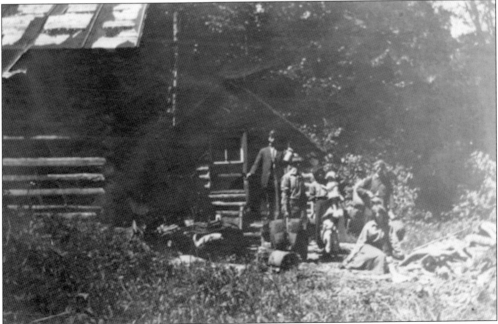

Written on the back of this scene is, "Indian Lake, Ham. Co NY 'Our hunting Paradise' 1901." The exact location of the camp and its owner are unknown, but this is a great example of an early-Adirondack hunting camp. It is unclear whether the white material on the tar-paper roof is clothing or hides drying in the sun.

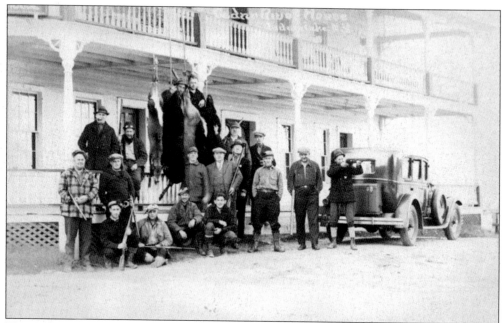

The Cedar River House, originally known as the Arctic Hotel, catered to fishermen, golfers, hunters, and tourists. This successful hunting party, which was staying at the hotel, has proudly displayed its bounty from the day's hunt. The hunter on the far right hated to quit and must have been aiming at a buck on the ninth green of the Cedar River Golf Course.

James and Nancy Fagan lived in the old Tucker Farm south of the Beaver Meadow Flats. For years, they provided lodging for hunters visiting from New York City, with James acting as guide. James, sitting in the center with his son Tom, is surrounded by visiting hunters. These men made the trek from New York City to Indian Lake year after year to enjoy the hospitality of the Fagans.

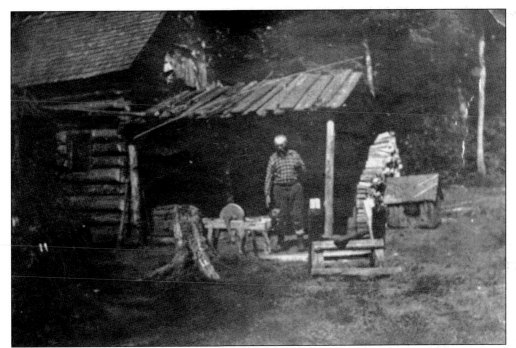

"Burt [sic] Brown" is marked on the back of this photograph, along with "Moose River Plains—Indian Lake." Bert Brown, nicknamed "Wanakee," was born in 1890, served in World War I, and was a lumberman and guide by trade. Shown here, his hunting cabin has a good roof, his wood is piled, his lantern is lit, and with man's best friend by his side, what more could Brown ask for?

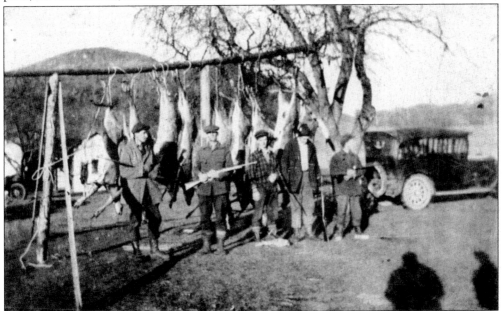

By the looks of the nine trophies hanging behind Adirondack guide Horace Hutchins Sr. (at center wearing a plaid coat), this must have been a terrific day of hunting in the Bullard Mountain area of Big Brook. The party members were guests at the Chimney Mountain House resort where Hutchins was a hunting guide.

Camp Perkins, Jessup's River, Adirondack Mts.

Camp Perkins at Perkin's Clearing was a 19th-century post, store, and lumber camp. Many social events took place at the clearings of Camp Perkins, including picnics, baseball games, and church socials. It was a great gathering place for the townspeople of Newton's Corners (Speculator), Lake Pleasant, and Indian Lake. Above, a social event is about to commence, as the tables are prepared, and the cars are beginning to arrive. Below, the guides and hunters are showing their day's kill with pride. Notice the distinguished, white-bearded gentleman postured on the porch behind the hunters. This was the famous hermit Alvah Dunning, who roamed the Adirondacks and, whenever the opportunity arose, would sneak into any picture being taken. This is a great example of this old Adirondack hermit's favorite pose. Dunning loved to have his picture taken, anywhere, anytime.

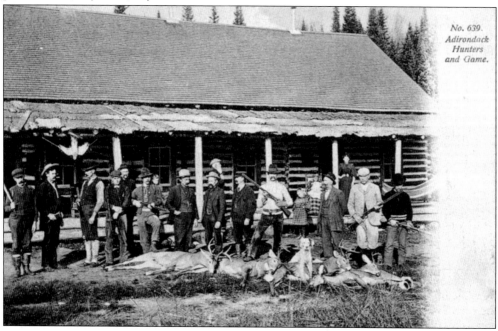

No. 639. Adirondack Hunters and Game.

Lillian (Hall) McCane and her husband, William, were photographed in July 1943, reverently standing next to the World War II honor roll memorial. This memorial listed 161 names of the men from the town who served in the branches of the military during the World War II. Lillian, responsible for the creation of this monument, was a leader in the town's veterans' affairs.

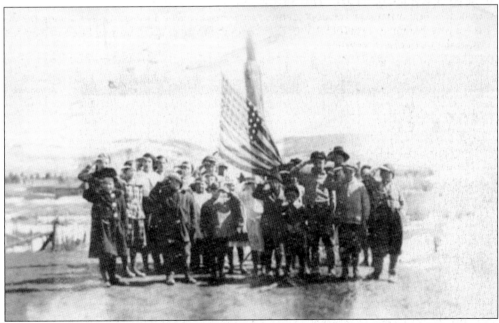

Since the founding of Memorial Day, or Decoration Day, by members of the Grand Army of the Republic in 1868, students everywhere have celebrated the day with patriotic activities. During the early 1900s, students at the Indian Lake School gather on the lawn to have their picture taken observing this day while spiritedly saluting the American flag.

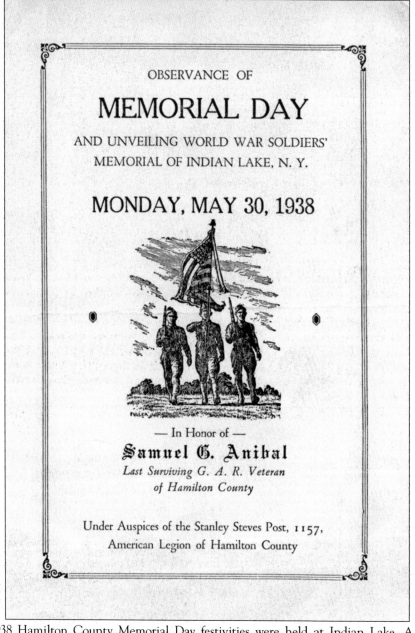

OBSERVANCE OF

MEMORIAL DAY

AND UNVEILING WORLD WAR SOLDIERS'
MEMORIAL OF INDIAN LAKE, N. Y.

MONDAY, MAY 30, 1938

— In Honor of —

Samuel G. Anibal

*Last Surviving G. A. R. Veteran
of Hamilton County*

Under Auspices of the Stanley Steves Post, 1157,
American Legion of Hamilton County

The 1938 Hamilton County Memorial Day festivities were held at Indian Lake. A parade proceeded from the east end of town and featured six musical units and 29 organizations and civic bodies from Hamilton County. At the ceremony, the World War I veterans' memorial monument was unveiled at the school grounds. Special recognition was given to Lillian McCane for her patriotism and hard work. Special honor was also paid to Samuel B. Anibal, age 91, who was the only surviving Civil War veteran in Hamilton County in the year 1938. He was grand marshal of the parade. The address was given by Dr. George Stropt of Gloversville. Following the parade, an exhibition by the drum and bugle corps was given on the athletic fields of the school grounds. An estimated 5,000 people crammed the streets of this small community for these Memorial Day observances.

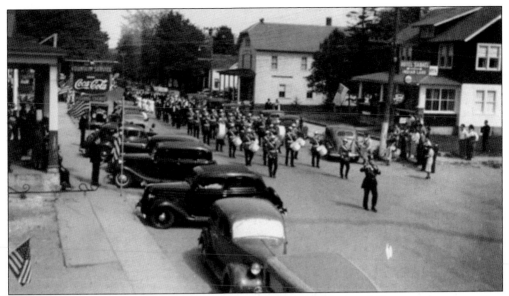

This is a picture of the May 30, 1938, Hamilton County Memorial Day parade, proceeding down Main Street in Indian Lake. Leading the units is the Harold Wilmot Post No. 137 Drum and Bugle Corps from Gloversville. The procession is heading west on Main Street toward the high school where the celebration would continue. The image below was taken of the speaker area and the assemblage on the school lawn. Festivities of the day concluded at the Soldiers Memorial Park on the high school grounds, where the unveiling of the World War I soldiers' memorial took place. The monument stood under the vertical American flag directly ahead of the speaker.

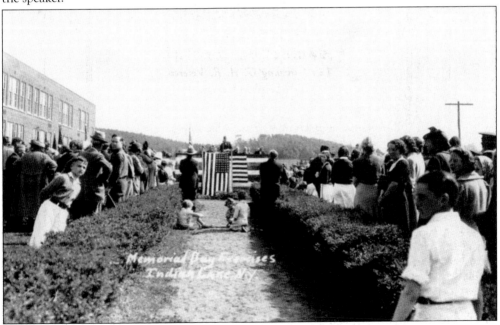

This is a view of the World War I soldiers' memorial as it stands today on the lawn of the Indian Lake Central School. Thirty-eight World War I veterans from this small community have their names inscribed on the monument. This area was once called the Soldiers Memorial High School Grounds, according to the program at the memorial's unveiling. The World War II veterans' honor roll memorial was first placed on the lawn next to the William McCane building. It was then moved to the Odd Fellows hall across the street. Because the Odd Fellows building became the location of the fire hall, the memorial board was moved for the third and final time to the lot next to Marty's Hotel on Southwest Main Street. The memorial has since been dismantled.

While Gordon DeMarsh was dutifully serving his country during World War II while having left a wife and seven children at home, two of his sons and a friend show their loyalty by saluting the country's flag. Pictured here are, from left to right, Gordon DeMarsh Jr., friend Alan Chatterton, and Lloyd DeMarsh. Both brothers helped their mother at home with the chores and other household duties. After this picture was taken, the three boys changed from their navy blues to their work clothes and plowed a small vegetable garden for the family. Each brother took a turn pulling the plow manually, as no horse was available. With the help of the American Red Cross, Indian Lake town physician Dr. Hubert F. Carroll and Indian Lake school principal Milton S. Pope, DeMarsh was eventually discharged from military duty and returned home to support his large family.

ACROSS AMERICA, PEOPLE ARE DISCOVERING SOMETHING WONDERFUL. *THEIR HERITAGE.*

Arcadia Publishing is the leading local history publisher in the United States. With more than 3,000 titles in print and hundreds of new titles released every year, Arcadia has extensive specialized experience chronicling the history of communities and celebrating America's hidden stories, bringing to life the people, places, and events from the past. To discover the history of other communities across the nation, please visit:

www.arcadiapublishing.com

Customized search tools allow you to find regional history books about the town where you grew up, the cities where your friends and family live, the town where your parents met, or even that retirement spot you've been dreaming about.